BETTER PICTURE GUIDE TO
Photographing
Colour

RotoVision

A RotoVision Book
Published and Distributed by RotoVision SA
Rue Du Bugnon 7
1299 Crans-Près-Céligny
Switzerland

RotoVision SA, Sales & Production Office
Sheridan House, 112/116A Western Road
Hove, East Sussex, BN3 1DD, UK

Tel: +44 (0) 1273 72 72 68
Fax: +44 (0) 1273 72 72 69
E-mail: sales@RotoVision.com

Distributed to the trade in the United States by:
Watson-Guptill Publications
1515 Broadway
New York, NY 10036
USA

ISBN 2-88046-493-5

Book design by Brenda Dermody
Diagrams by Roger O'Reilly

Production and separations in Singapore by ProVision Pte. Ltd.
Tel: +65 334 7720
Fax: +65 334 7721

BETTER PICTURE GUIDE TO

Photographing
Colour
composition & harmony

MICHAEL BUSSELLE

Contents

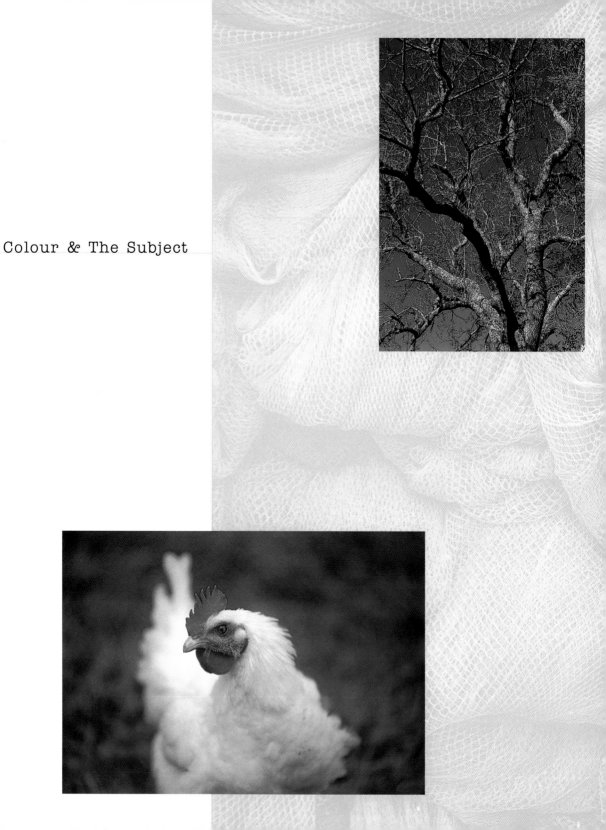

Colour & The Subject

1

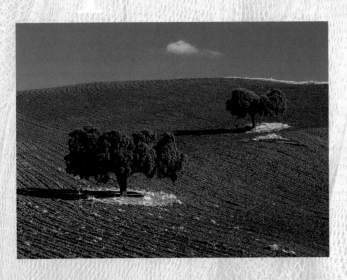

Subjects which are capable of producing good colour photographs can be found almost everywhere. From close-ups to landscapes and portraits to architecture, the key element in producing striking colour images is primarily the ability to spot the potential within a scene or setting and to recognise how its colour qualities can be best revealed by the way in which it is photographed. The aim of this chapter is to show something of the wide range of possibilities which can be found in very differing situations.

Colour in the Countryside

A well-known landscape photographer was quoted as saying that they preferred shooting landscapes in black and white, because the dominant colour of the countryside, green, was so uninteresting. This is largely true and it's quite noticeable that many of the most striking colour landscape images are those which include colours which are either unfamiliar or unexpected. Bold and dramatic colours are found readily in the countryside and you need to develop an eye for them.

Seeing

This scene came into view as I drove through the Champagne vineyards in France late one autumn day. The vine leaves had turned to this beautiful shade of burnished gold and it was this rich colour which caught my eye in the first instance; together with the pattern effect which the orderly planting had created.

Thinking

Although the scene looked stunning, I felt that the colour and the pattern would not, on their own, produce a strong enough image. So I drove around for a while, looking for something which would create a focus of attention. I thought that this small stone hut would work very well; but this particular viewpoint meant that I had to shoot directly into the sun, which was quite low in the sky.

This picture was taken in December, late in the afternoon, in the South Hams region of Devon, UK. The vivid green of the newly emerging crop was the thing which first appealed to me. I found a viewpoint which enabled me to use the gate in the hedgerow as a focus of attention and framed the image quite tightly using a long-focus lens to enlarge this quite small area of the scene.

Technical Details
Medium format SLR camera with a 300mm zoom lens, an 81B warm-up filter and Fuji Velvia.

This illustration shows how the composition would have lacked focus without the gate breaking the line of the hedge.

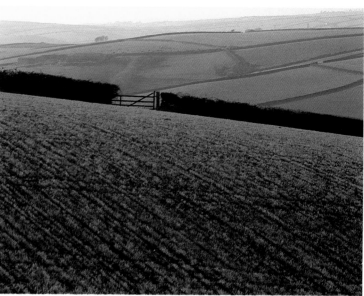

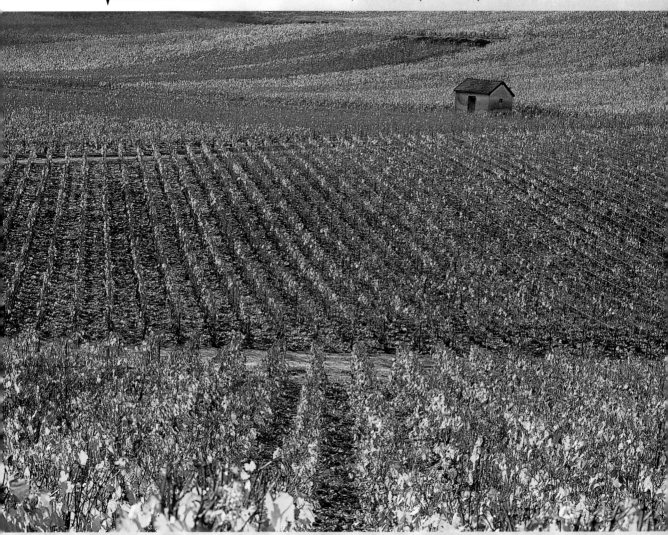

Acting

I used a long-focus lens to isolate the most striking area of colour and framed the image so that the hut was between the corner of the frame and the intersection of thirds. Because the sun was shining directly onto the lens causing a flare, I used a piece of black plastic supported on a bendy arm attached to the camera's hot shoe to cast a shadow over it. I fitted an 81C warm-up filter to enhance the rich colour of the vine leaves.

Rule of Thumb

When deciding the best way to frame the image, it is easier if you first identify an object, tone or colour which can be used as the main focus of attention. Once you have done this it then becomes more apparent as to how the camera should be angled to position it in the frame and how tightly the image should be framed in order to create the most balanced and effective composition.

Colour in the Countryside

Seeing

I spotted this rich red tree while travelling through the Meuse region of France in late autumn. It was not only its colour but its shape that I found appealing and the fact that the green meadow created a bold contrast. The pale yellow trees behind had also created a strong tonal contrast which helped to emphasise the shape and colour of the tree.

Thinking

It was a hazy day with very little directional light and not much subject contrast so I decided to frame the image quite tightly, using a long-focus lens, so that the darker tone and rich colour of the tree became the dominant element.

Technical Details

▼ 35mm SLR camera with a 75–300mm zoom lens, 81C warm-up and polarising filters with Fuji Velvia.

I was driving through the Auvergne region of France in early summer when I saw this scene. I have a strong liking for isolated trees and it was this which first caught my eye. It was a dreadful day with heavy clouds but this has created a very top-lit look with the tree and meadow strongly lit but the forest behind in shadow. The effect is one of a virtually monochromatic image with almost every shade of green between pale pastel and black. I framed the image so the centre of the tree was about on the intersection of thirds.

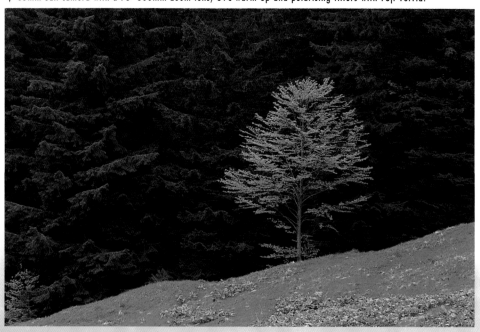

Technical Details

▼ 35mm SLR camera with a 75–300mm zoom lens, 81C warm-up and polarising filters with Fuji Velvia.

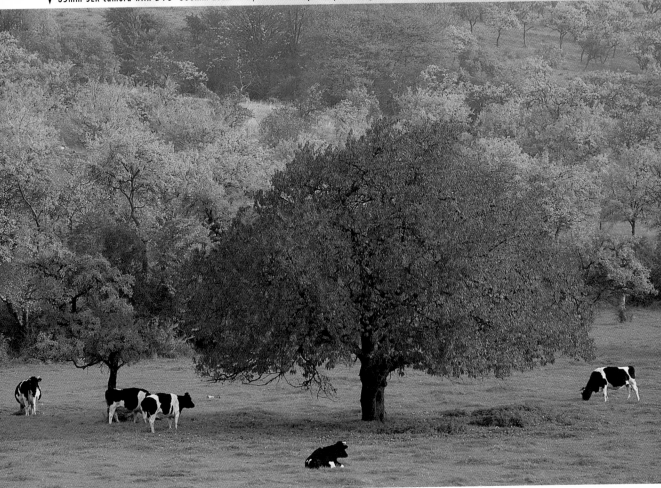

Acting

I found that a polarising filter increased the colour saturation significantly and I added an 81C warm-up filter to further enhance the rich colour. The position of the cows was also an important factor as they were quite dominant because of the small areas of contrast they created and I waited until they moved into the most pleasing position.

This illustration demonstrates how the impact of the picture would have been diminished had the isolated tree been a brown colour rather than the rich red of late autumn.

Colour in the Countryside

Seeing

I was driving through the French region of the Aube, an area of open, rolling farmland, when I saw this field of dead sunflowers awaiting the harvest. It was partly the dominant single colour of the crop, creating an almost sepia image, which attracted me but also the light-toned winding track which led through the field.

Thinking

The track created the most pleasing shape as it rose up the hill so I decided to look for a viewpoint which showed as much of this section as possible. I was now quite distant and I needed to use a long-focus lens to isolate this particular area of the scene.

Technical Details
▼ 35mm SLR camera with a 100–300mm zoom lens, 81B warm-up filter with Fuji Velvia.

The remote and dramatic region of Spain's Maestrazgo was the location for this picture. My visit coincided with the approach of a violent thunder storm which raged for several hours. At this point the dark grey clouds had almost enveloped the sky but for a small gap which allowed the sun to spotlight a small area of the landscape below. It is the intense colour of the brightly-lit red soil, and the bold contrast with the very dark sky and shaded landscape, which has created this striking effect, but it lasted for only a few seconds before the clouds closed in.

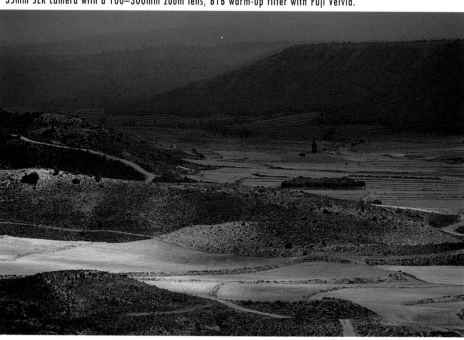

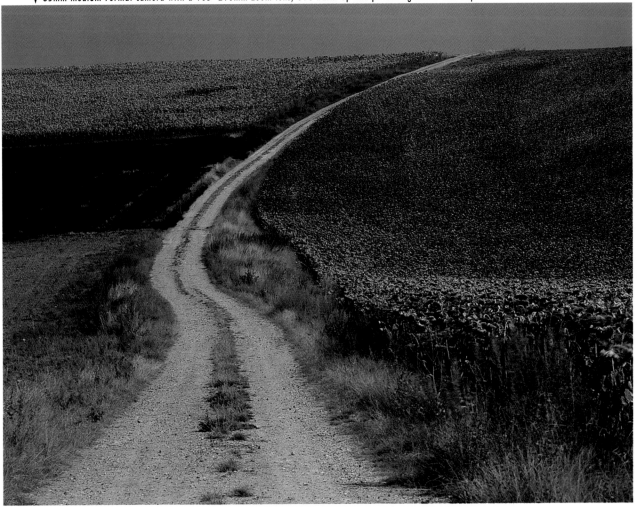

Acting

I wanted the track to run across the frame so I altered my viewpoint slightly and angled the camera to make the left side of the track in the foreground lead out of the bottom right-hand corner of the image while the top of the track led towards the top right-hand corner, creating a diagonal line.

Rule of Thumb

Contrast can be a powerful element in an image, not just tonal or colour contrasts but also those created by shapes and lines. The landscape tends to be dominated by horizontal lines which is why the upright line created by a tree, for instance, can be so striking in a photograph. The same is true of a diagonal line which can also add a more dynamic element to a composition.

Urban Colour

Towns and cities can be rich sources of subject matter for the colour photographer. From shop windows to billboards, architecture, transport and a huge variety of ephemera, the concentration of man-made structures, design and decoration to be found in the urban environment can provide a fruitful hunting ground for an observant photographer. The colours, shapes and patterns to be found on many streets will help to produce images with a strong sense of design and a bold graphic quality.

Seeing

It was the combination of the very bright red paint and the highly polished chrome of this car, seen in Los Angeles, which attracted my attention. But it was parked in a busy street and the background was untidy and distracting.

Thinking

I thought that I could overcome the problem of the background by framing the subject very tightly which would also accentuate the colour of the paint work and the tactile quality of the chrome.

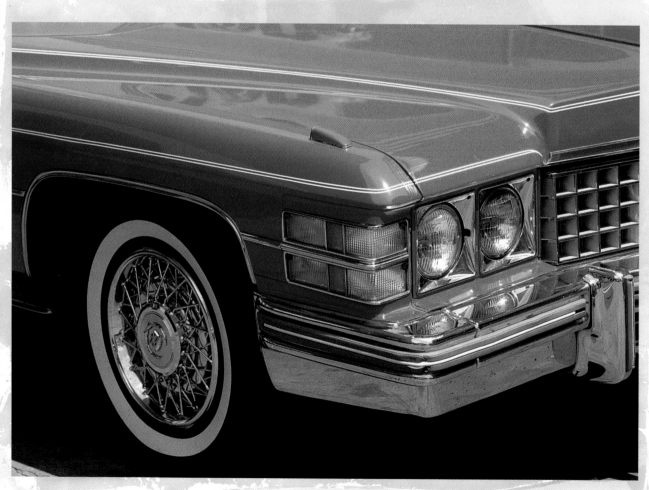

This picture, taken in Los Angeles, appealed to me because of the contrast between the flag and the building behind with its rather abstract reflections. I chose a viewpoint which placed the two green highlights each side of the flag and used a long-focus lens to frame it very tightly.

Technical Details
▼ 35mm SLR camera with a 75–300mm zoom lens, an 81B warm-up filter with Fuji Provia.

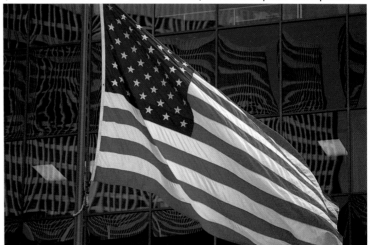

Acting

I chose a viewpoint that gave me a 3/4 frontal view of the car. This created a nice sense of perspective and enabled me to include all of the wheel and part of the radiator grid. I then framed the image so the wheel was on the base of the frame and the car's bonnet filled the top of the frame, at the same time excluding the background.

◄**Technical Details**
35mm SLR camera with a 35–70mm zoom lens, an 81B warm-up filter and Kodachrome 64.

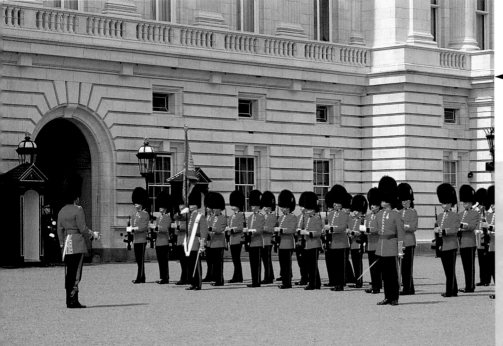

◄**Technical Details**
35mm SLR camera with a 75–300mm zoom lens, an 81B warm-up filter with Fuji Provia.

Changing the guard at Buckingham Palace must be one of the most photographed subjects in the world and it is indeed a colourful and exciting event. This shot was taken at the beginning of the ceremony and I had to be there early to get a good viewpoint. This enabled me to shoot through the railings with a long-focus lens and frame the image so that only the red uniforms and the neutral-coloured facade of the palace were included in the picture.

Urban Colour

Seeing

The island of Burano in Italy's Veneto region was the location of this shot where all the houses are painted in the most extraordinary range of vivid colours. The initial impact is almost overwhelming and it took me a while to begin to see the wood from the trees. I liked the juxtaposition of the three coloured houses in this scene and the fact that they were on different planes and, although seen from the front, there was a sense of perspective.

Thinking

My choice of viewpoint was determined by the desire to keep a quite frontal view of the house in the foreground but to show as much of the mustard-coloured house as I could.

Acting

Shooting using the normal format would have included a large area of the paved street and would have also included a larger area of sky above the background houses and I felt this would have diminished the effect of the colourful facades. For this reason I decided to use a panoramic format which, effectively, gives a long-focus effect at the top and bottom of the image but allows a wide-angle view of the horizontal aspect of a subject.

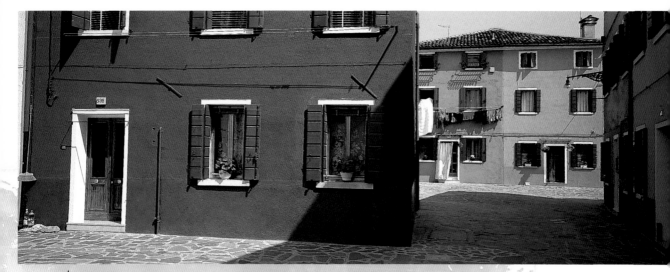

▲ Technical Details

35mm Viewfinder camera with a 45mm lens, an 81A warm-up and Fuji Velvia.

Technical Details
▼ 35mm SLR camera with a 35–70mm zoom lens, an 81B warm-up filter and Kodak Ektachrome 64.

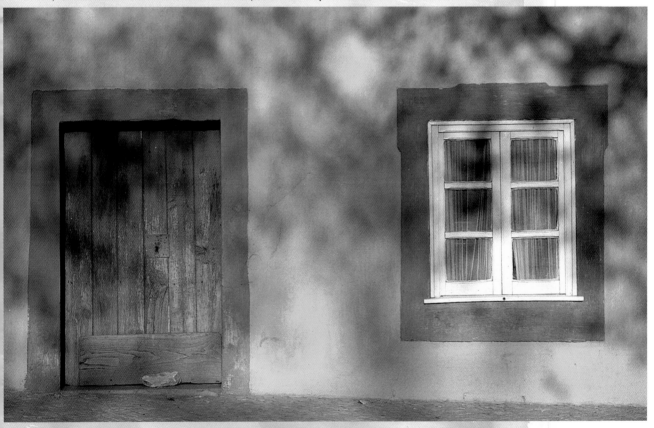

I saw this colourful doorway in a town in Portugal's Algarve where this colour combination is very typical of the region. Apart from the obvious appeal of the contrast between the blue door and window frames and the yellow wall, I was also attracted by the shadowy effect the sunlight had created. I shot a number of pictures from different angles which gave some perspective to the image but decided I liked this version best, shot straight on it had a two-dimensional quality which has accentuated the graphic effect of the two blue rectangles.

Urban Colour

Seeing

A grey, wet morning in Venice did not seem to be the most auspicious occasion on which to find pictures but it had caused the cafés in St Mark's square to be completely deserted. I have always been attracted to places which seem made for crowds and lots of activity. When they are deserted, like seaside resorts out of season, they become atmospheric.

Thinking

I liked the combination of muted yellow and grey in this particular scene which seemed to emphasise the mood of the occasion. I wanted to make a picture which was quite simple and which made the most of the shapes of the tables and the pattern they created as well as trying to capture the atmosphere of a rainy day in Venice.

Acting

I looked for a viewpoint which placed the tables along a diagonal line as this would give the composition a more dynamic quality. I stood on tip toe to shoot from the highest angle I could manage, so that the tops of the tables formed an ellipse, and framed the image to crop the bottom and side of the chair and table in the foreground. I also ensured that the square beyond the tables was excluded as people were walking there and they would have spoilt the rather forlorn atmosphere of the picture.

Technical Details
35mm SLR camera with a 24–85mm zoom lens, 81A warm-up filter and Kodak Ektachrome 100 SW.

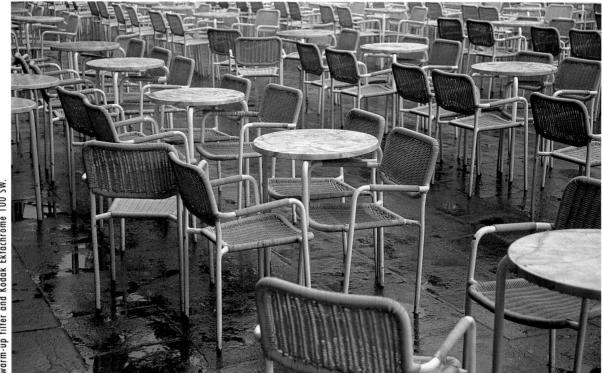

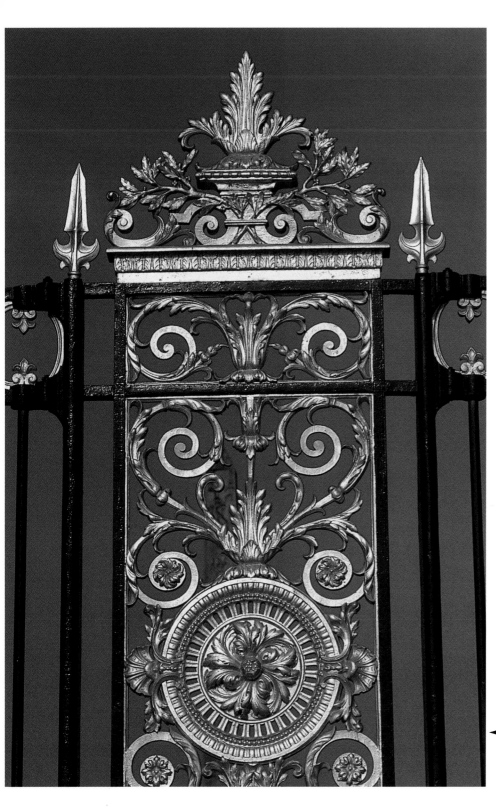

This is one of the gateways to the Tuilerie gardens in Paris, a magnificently ornate and richly gilded structure. My interest in it was aroused because of the lighting. Shooting from a front-on viewpoint the bright sunshine was angled in such a way that it revealed a wonderfully textural, tactile quality as well as enhancing its colour. The deep blue sky behind had created an ideal backdrop and the contrast it created emphasised the shapes and patterns within the gate. I framed the image quite tightly in order to fill the frame in the most effective way and gave slightly less exposure than was strictly correct, which has accentuated the texture of the metalwork as well as producing a more dramatic quality.

◄ Technical Details

35mm SLR camera with a 35–70mm zoom lens, 81A warm-up and polarising filters with Fuji Velvia.

Colour in Nature

Every colour and hue in the visible spectrum can be found in nature. From close-up images of flowers to forest trees and rock formations, there is often no need to travel very far from your doorstep to find a virtually limitless choice of subject matter. Because we are so familiar with natural forms it is often only those which are particularly dramatic which catch our eye but the colours of the rocks on a shoreline, for instance, can be used to produce equally powerful colour photographs.

Seeing

I saw this fine field of poppies near my home in the Darent Valley in Kent, UK, its blaze of colour was visible from a considerable distance away. On approaching the field I saw that the poppies were not growing as densely as it seemed from a distance and there were large areas of grass between the blooms.

Thinking

But I felt there was potential in the scene and I looked for a viewpoint which placed the most colourful area of the field in the foreground of the image as well as one which would allow me to use the row of trees as a backdrop. This was important as it was a hazy day with a white sky and I wanted to make sure this was excluded.

A field of sunflowers is an almost irresistible subject but it's not as easy to find one which is photogenic as you might think. Often the blooms are facing the wrong way for the light or their heads are drooping. I found this field in Provence and the blooms not only had their heads up and facing the right way but the field was on a lower level than the road alongside it, which has enabled me to use a high viewpoint. I decided to frame the image quite tightly using a long-focus lens to emphasise both the subject colour and the pattern effect of the blooms.

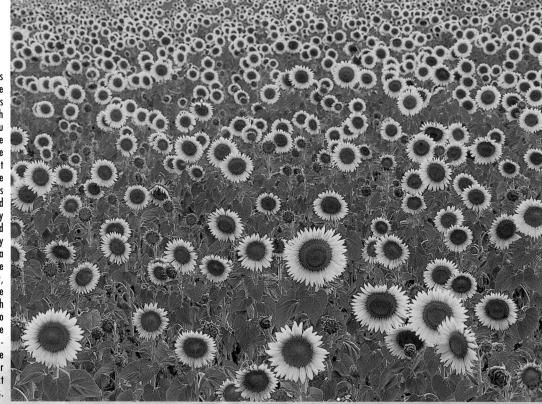

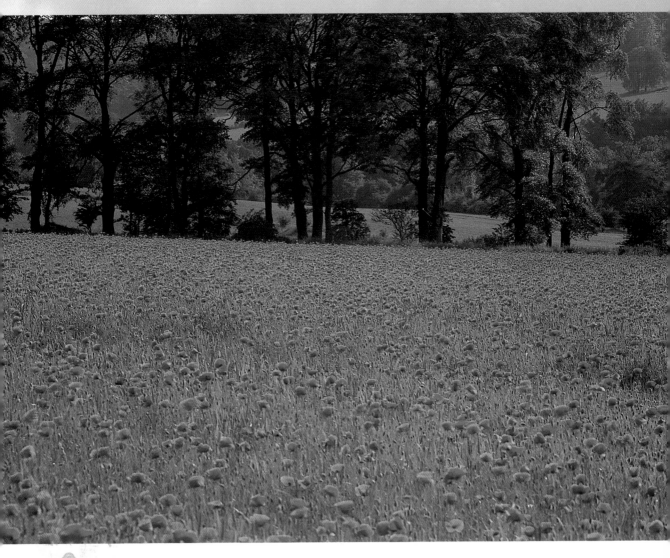

Acting

I decided to use a long-focus lens both to isolate a small area of the scene and to create the effect of compressed perspective, which would make the blooms seem denser and emphasise their colour. I used both a warm-up filter and a polarising filter to obtain the maximum saturation from both the red flowers and the green grass.

Rule of Thumb

Choosing a viewpoint is one of the most important decisions to be made when taking photographs. Many photographers tend to shoot from the place where they first see the subject but it always pays to explore all the possibilities before exposing film if time allows.

▲ Technical Details
Medium Format SLR camera with a 300mm lens,
81C warm-up and polarising filters with Fuji Velvia.

◄ Technical Details
Medium Format SLR camera with a 105–210mm zoom lens,
81C warm-up and polarising filters with Fuji Velvia.

Colour in Nature

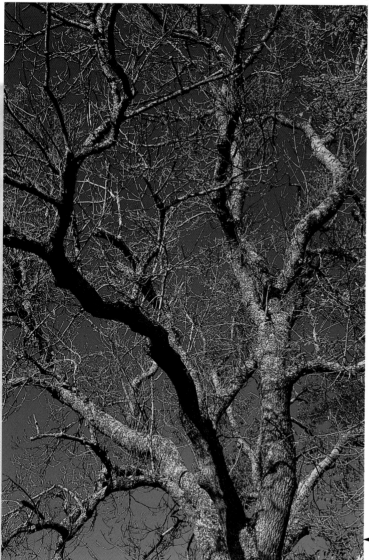

Seeing

This curious landscape is in the Navarre region of Spain, close to the Pyrenees. Here, small fields are enclosed in neat, curvaceous terraces which I find very attractive. I have visited this location before in the summer and was astonished to see how much the autumnal change had altered its appearance, with the stubble left from the harvested grain and the parched land surrounding the fields creating an almost sepia effect.

Thinking

Because the scene had such a limited colour range, it would probably have looked great as a black and white picture too, I felt it would be best to emphasise the shapes and pattern the fields had created as well as enhancing the textural quality of the landscape.

I saw this tree as I drove through the countryside in the Medoc region of France. It was early spring and the newly emerging foliage had not yet obscured the shape and texture of the tree trunk and branches. I liked the contrast between the golden branches and the deep blue sky and the sunlight was at a perfect angle emphasising both shape and texture. I chose a viewpoint close to the base of the tree and used a wide-angle lens to include enough of the subject to create a balanced composition. I used a polarising filter to make the sky a richer, deeper blue and to increase the colour saturation of the bark.

Technical Details

35mm SLR camera with a 17–35mm zoom lens, 81C warm-up and polarising filters with Fuji Velvia.

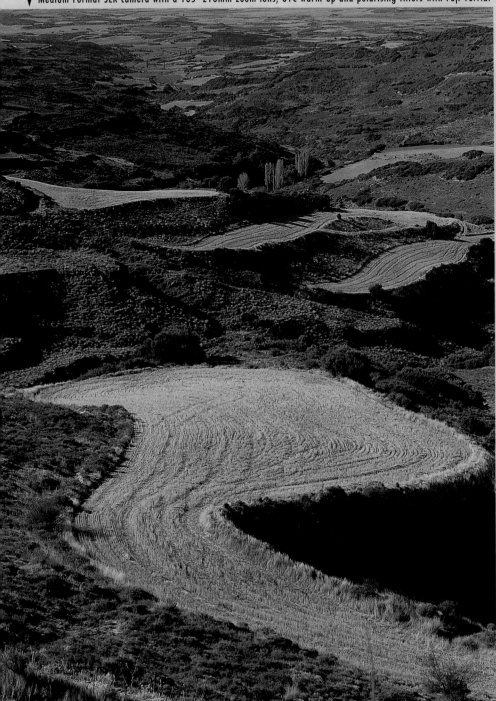

Acting

I chose a viewpoint which placed the closest field directly in the foreground and in a way which showed how it curved away from the camera towards the other, more distant fields. I used a long-focus lens to frame the image so that the foreground field trailed out of the bottom right corner of the frame and in a way which also allowed me to exclude the sky which was pale and weak in colour.

Colour in Nature

Seeing

The Landes forest in south west France was the location for this picture and I was lucky enough to be passing through when the heather was at its **peak of colour**. It was a very dull, overcast day, in fact it was **raining lightly** when I took this shot, but this has enhanced the **subtle colour** of the heather and ensured that the dark forest behind did not create too much contrast.

Thinking

I looked for a **viewpoint** which created the most pleasing and balanced **arrangement** of the tree trunks and which also placed a good patch of the heather into the immediate **foreground**.

Acting

I framed the picture using a long-focus lens to **isolate** the most effective area of the scene and adjusted the camera so that the heather occupied slightly **more than half** of the picture area. I used a weak **warm-up** filter to prevent the heather and green foliage becoming too blue and a polarising filter to maximise the colour saturation.

The colour of this bougainvillia petal was so intense that I felt that it needed nothing more in the frame to make a striking image. The plant was in a shaded spot and the very soft daylight was ideal for such a close-up image as well as being the most effective lighting to enhance the leaf's rich colour and subtle texture. I used a macro lens to enable me to use a close enough viewpoint to frame the image very tightly and selected a small aperture to ensure there was enough depth of field.

Technical Details
35mm SLR camera with a 90mm macro lens and Fuji Velvia.

Technical Details

▼ Medium Format SLR camera with a 105–210mm zoom lens, 81A warm-up and polarising filters with Fuji Velvia.

Colour & Detail

In normal circumstances, when looking for subjects to photograph, we tend to think in terms of specific objects or scenes and approach that subject so that its identity is clearly defined. When the intention is primarily to make a photographic record of a place or object, the way in which the image is framed and composed will be, to some extent, restricted by this need. If, however, the sole purpose of the photograph is to produce a powerful eye-catching image, as opposed to a recognisable representation, then it is possible to have a more uninhibited approach and to simply look for the most telling aspects and details of the subject.

Seeing

I saw this boat moored alongside a Venetian canal and was immediately attracted by the name. Lettering invariably has an eye-catching quality when included in a picture, especially when the name itself and the style of the lettering are as nice as this.

Thinking

I wanted the lettering to dominate the image but I also wanted to make the most of the bright contrasting colours of the subject in general.

Acting

I looked for a viewpoint which placed the lettering directly below the triangle of orange tarpaulin and one which also allowed me to place the capstan off centre. I framed the shot so that the name filled the frame and the edge of the boat ran more or less along the centre of the image.

The impact of this picture would have been reduced had the image been framed less tightly.

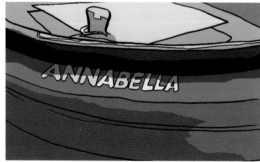

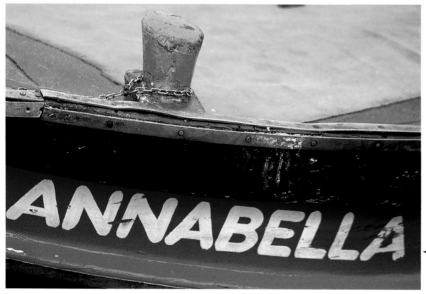

Technical Details
35mm SLR camera with a 24–85mm zoom lens, an 81A warm-up filter with Kodak Ektachrome 100 SW.

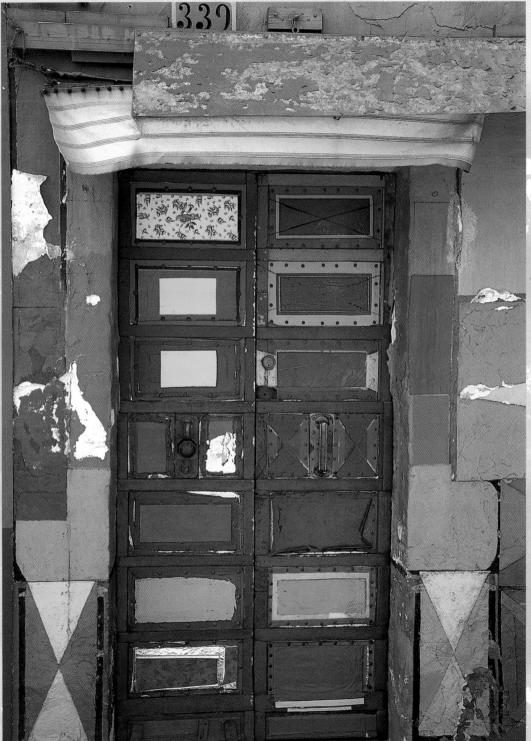

Technical Details
35mm SLR camera with a 24–85mm zoom lens, an 81A warm-up filter and Kodak Ektachrome 100 SW.

This extraordinary doorway is in a small street on the island of Burano, Italy. I kept the image very simple, shooting from almost front-on and framing the image so that just the doorway and surrounding pillars filled the frame.

Colour & Detail

Seeing

My attention was caught by this blue mooring post in a quiet canal in Venice, Italy. I find that while blue in nature is quite commonplace, such as in skies and flowers, and often goes unnoticed somehow it often commands attention when seen elsewhere.

Thinking

My first thought was to take a very close-up shot of the pole, using a long-focus lens to fill the frame with just its top. This would have made more of the colour and made the gold decoration more noticeable, but I also wanted to establish something of its location.

This detail is from the Doge's Palace which overlooks St Mark's Square in Venice. It was largely the quality of the light which made me want to photograph it. In the late afternoon the sun was being reflected down towards my camera creating a rich texture and attractive highlights on the gilding. I used a long-focus lens to fill the frame with the gilded parts of the sculpture, and I also used a polarising filter to increase the colour saturation of the sky.

Technical Details
35mm SLR camera with a 100–300mm zoom lens, 81C warm-up and polarising filters with Fuji Velvia.

Acting

I looked for a viewpoint which would enable me to use a detail in the background to act as a compositional foil to the slender, upright post. By walking a little way along the canal I found that I could place the post in the centre of this archway in a canal-side building, and the contrasting shapes seemed to make the picture more interesting. This viewpoint also placed the post against a very dark tone which has helped to make the post stand out more clearly.

Colour & Detail

Seeing

I'd bought a pumpkin for a still-life arrangement and after photographing it, I had forgotton it was still around. It was a week or two later that I noticed it again and it had begun to rot in a very colourful and spectacular way.

Thinking

I decided to watch its progress with a view to shooting another picture of it and in fact did so on a couple of occasions before it reached this state when parts of it had turned almost crimson.

Acting

The crimson areas were quite small and isolated so I decided to shoot a very close-up image using a macro lens. Doing this enabled me to select the most striking part of the pumpkin and to produce a picture with an almost abstract quality. I framed the shot so that the yellow core of the fruit was just off-centre and in a way which included an area of the brown skin in the bottom right corner of the frame to balance the bold splash of red. I used a small aperture to ensure there was enough depth of field.

Technical Details
▼35mm SLR camera with a 35–70mm zoom lens, an 81A warm-up filter with Kodak Ektachrome 64.

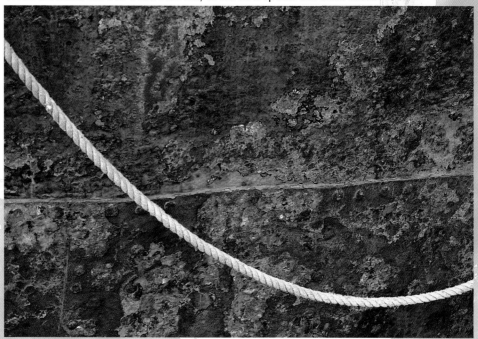

Among other things, I have a fondness for rusting metal and I found this example in a boatyard. I liked the rich but limited colours and the loop of white rope which created both an effective contrast as well as adding a vital element to the composition. I framed the shot so that the rope created a semi-diagonal line across the metal and the black and brown parts of the rust were more or less equal.

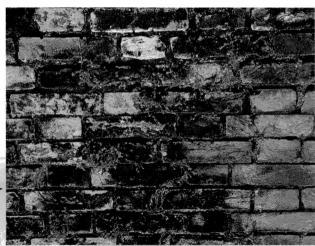

I liked the rich rust colour of the bricks in this shot together with the patches of black and green. The colours seemed particularly strong and I used a close viewpoint to frame the most interesting section of the wall quite tightly. I used a frontal viewpoint as I wanted to emphasise the pattern which the regular rectangles of the bricks had created.

Technical Details
35mm SLR camera with a 24–85mm zoom lens, 81A warm-up filter with Kodak Ektachrome 100 SW.

Technical Details
35mm SLR camera with a 90mm Macro lens and Fuji Velvia.

Everyday Colour

Many photographers believe that it's necessary to make a special excursion in order to take good photographs. It's certainly true that if you travel to an unfamiliar environment the photographic possibilities seem much greater than in your own. A photographer from, say, Dublin would doubtlessly be overwhelmed by the potential on his first visit to somewhere like Marrakesh or Jaipur. But of course the converse is also true and the key to seeing good pictures has as much to do with looking with a fresh eye at familiar surroundings as it is to do with the stimulation which a completely new destination can provide.

Seeing

I came across this nice old horse while passing through a small village in Cantabria, Spain. Although the horse itself aroused my initial interest I was also very taken by the almost luminous green of the stable door and the way it contrasted so well with the rich brown coat of the horse.

Thinking

The horse was tethered to the post and this threatened to be intrusive so I looked for a viewpoint where I had the clearest view of the horse's head and which also enabled me to have a good angle on the door.

Technical Details
▼ 35mm SLR camera with a 70–200mm zoom lens, an 81A warm-up filter and Fuji Provia.

The possibilities of this Bresse cockerel appealed to me because of his stark white plumage and the vivid splash of red on his comb and bill which contrasted strikingly against the green meadow. Taking the shot was difficult because he was constantly on the move, making framing difficult and I needed to find an angle where the splash of red would have the greatest effect. My patience was rewarded when, having moved almost directly towards me, he suddenly turned his head in a way which silhouetted it against his white feathers.

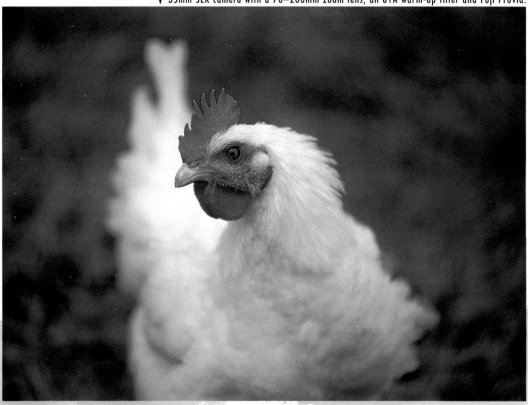

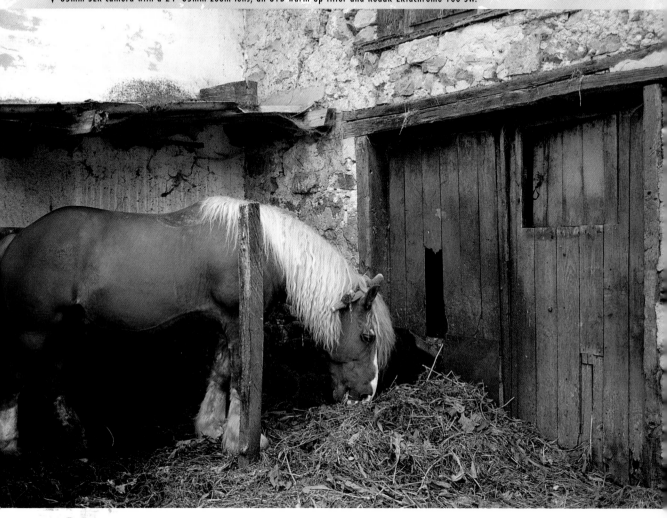

Acting

This seemed to be the best all-round position but I had to wait until the horse **moved further forward** and lowered his head onto the hay to prevent the post becoming too much of a **distraction**. I framed the shot so that all of the door was **included in the frame** as well as all of the horse.

Rule of Thumb

When photographing a moving subject it is best to use the fastest shutter speed that your film and the lighting conditions will allow as even a small amount of movement will cause the image to be blurred at slower speeds, especially when the subject is close to the camera or moving directly across your line of view.

Seeing

I spotted these two ladies whilst on a beach in Spain's Costa del Sol. The colour of their tanned skin and the **contrast** it created against the dark blue sea was very striking but it was the matching blue **plastic bags** which really made it for me.

Thinking

They were striding purposefully along the edge of the sea and I felt sure there was the possibility of a good picture if I could find the right viewpoint and pick **the right moment**. The difficulty was that there were many people swimming and the background was mostly very cluttered. It was also early evening and the sun was low in the sky and I needed to shoot from quite close behind them to avoid deep shadows and **excessive contrast**.

Technical Details
▼ 35mm SLR camera with a 20mm lens, 81C warm-up and polarising filters with Kodak Ektachrome 64.

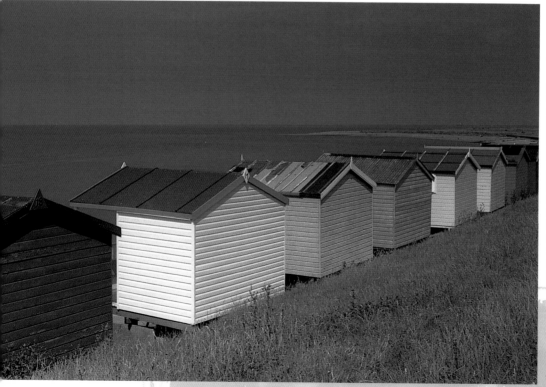

I came across this nice row of beach huts on the north Kent coast, UK. They had been painted an attractive assortment of colours which, although quite bright, I thought also had a balanced, harmonious quality. This was partly due to the organised, pattern-like nature of the subject. I chose a viewpoint which placed the huts at a diagonal across the frame and also set an area of blue sea in the background. Using a wide-angle lens, I framed the shot to include as much of the row as possible from a relatively close viewpoint and used a polarising filter to enhance the colour saturation of the sea.

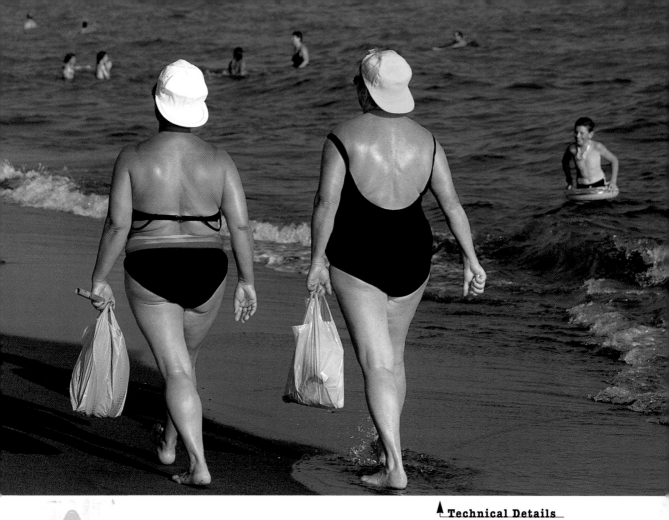

Acting

In the end I followed them for about 100 metres before finding this viewpoint with an area of sea behind them which was not too cluttered with swimmers. I framed the shot so that their feet were at the base of the frame and they were slightly to one side of the centre line, the boy on the right balanced the composition nicely. I waited until they had taken a stride before shooting.

▲ **Technical Details**
35mm SLR camera with a 100–300mm zoom lens and Kodak Ektachrome 100 SW.

Technical Tip

When using a polarising filter to make a blue sea or sky a richer colour and darker tone there is a risk that this will cause the camera's exposure meter to think the subject needs more exposure than is actually needed. It's safest to take a reading from a mid-tone in the scene, in this case I measured from the grass in the foreground.

Seeing

I was walking along the promenade at Herne Bay in Kent, UK when I spotted this red bench. It was a dull, overcast day and the sea was a drab grey but in a way this seemed to make the red bench even more interesting than had it been a sunny day with a blue sea.

Thinking

My first thought was to make a very symmetrical shot by shooting from side on to the bench and across to the sea. But this, I thought, produced a rather static and uninteresting image so I decided to look for alternative viewpoints.

Technical Details
▼ 35mm SLR camera with a 35–70mm zoom lens with Kodachrome 64.

I saw this blue-painted boat lying on the salt meadows which lay along the coast of northern France. The sheer simplicity of the image appealed to me and I felt that these two particular shades of blue and green worked so well together. It was a very overcast day and the light was very soft which has contributed to the gentle mood of the picture. I chose a viewpoint which showed the shape of the boat and framed it so that it was placed close to the base of the image and there was just a little space at either end of it.

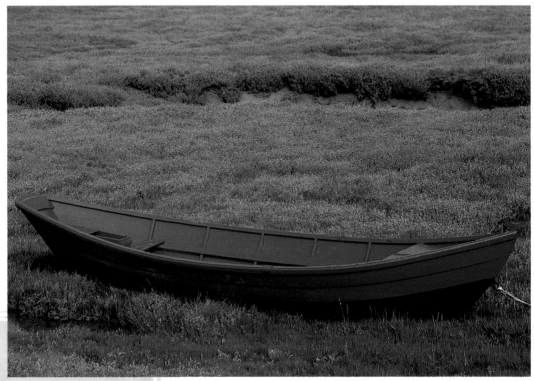

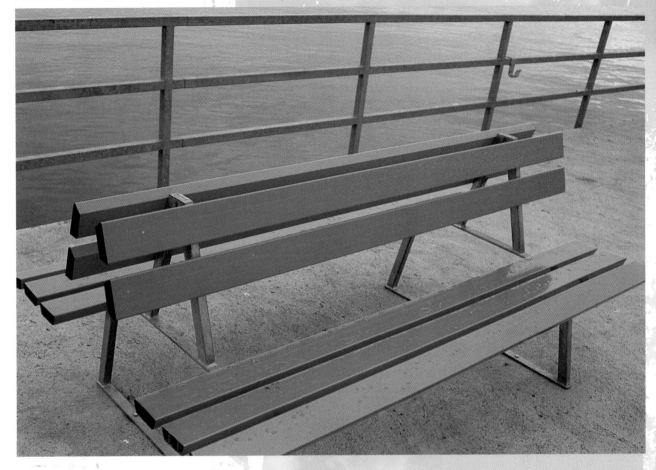

Acting

From this position, to one side of the bench and from a higher viewpoint, I found I could make the bench run across the diagonal of the frame. I was also able to place it so the upright supports behind were spaced evenly to each side and the top railing was parallel to the top of the frame, this satisfied my wish for an element of symmetry. By shooting from a high viewpoint, tip toes, I was able to exclude the sky, leaving the background as a plain unbroken shade of grey.

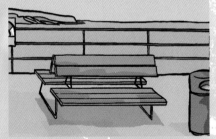

The illustration shows how a fractal viewpoint and wider framing would have produced a less dynamic composition.

Colour in Sky & Water

One of the most fascinating and ever-changing sources of colour in nature is that created by the interaction of light with the sky and water. Few photographers can resist the attraction of a striking sunset but there are many less obvious occasions when the atmosphere can create interesting colour effects in the sky such as at dawn and dusk. These effects can be given added interest when seen reflected in water, whether it is a tranquil lake or rolling surf at the edge of an ocean as well as the possibilities afforded by coloured objects reflected in a still or rippled surface.

Seeing

I'd set my alarm to wake very early in order to photograph the small seaside village of Barfleur in Normandy at first light and arrived at my chosen viewpoint, on the harbour wall, some time before sunrise. As I had a while to wait I watched the progress of the sun to the east and suddenly realised that some very nice things were happening in the sky with soft and subtle colours being created.

Thinking

I quickly began looking for a suitable viewpoint which would provide me with an interesting foreground. I thought this small group of rocks would do the trick and explored slightly different viewpoints in order to place them in the most pleasing juxtaposition. From this position, the water between the rocks was allowing some very nice reflections to occur.

Acting

The colours in the sky were changing rapidly as the sun rose higher and I started to shoot pictures using a neutral-graduated filter to make the sky slightly darker in tone. This enhanced the colour and also evened up the brightness difference between the sky and the darker foreground. The peak was reached quite quickly, the sun disappeared into cloud and within minutes it was just a dull grey day.

This was one of those lucky, opportunist shots which happen now and again. I was driving home after a day in the Sierra de Almijara in Andalucia when I passed the lake of Vinuela. It had been a very hazy day which had created this quite natural, warm orange glow in the sky as the sun began to set and I simply pulled over to the side of the road, used a long-focus lens to frame the most colourful section of the sky, and the most interesting section of the mountain range, and made my exposures.

Technical Details▶
35mm SLR camera with a 100–300mm zoom lens and Fuji Velvia.

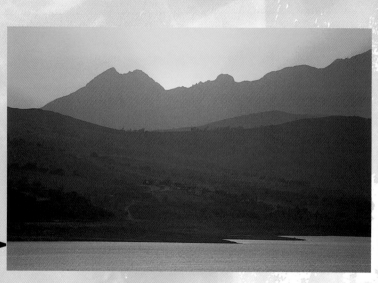

Technical Details
▼Medium Format SLR camera with a 55–110mm zoom lens, a neutral-graduated filter and Fuji Velvia.

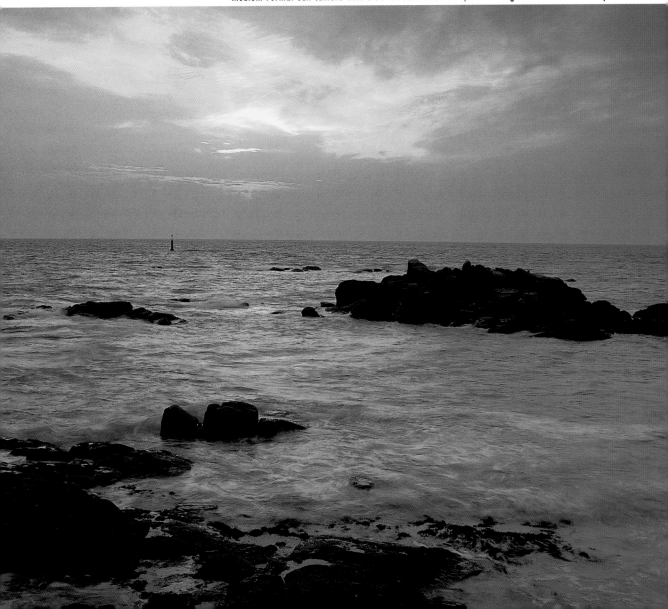

If the sky is white or blue we tend not to take too much notice of it, it is only when it takes on colour or is a very dark, stormy grey that it attracts attention. This threatening sky was looming over the vineyards in the Champagne region of France. Conditions like this change very quickly indeed and I had little time to set up and take the shot before it deteriorated. Although there was only weak sunlight, the white soil in the distance and yellow vine leaves in the foreground have created bright highlights and added contrast to the image. I framed the image to include the most interesting part of the sky and in a way which placed the white field just off centre. I used a neutral-graduated filter to make the sky look as dark on film as it did visually.

Technical Details
▼35mm SLR camera with a 75–300mm zoom lens, 81B warm-up and neutral-graduated filters with Fuji Velvia.

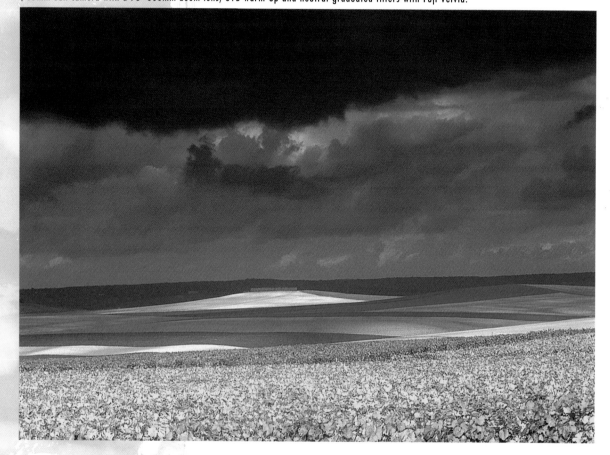

Seeing

I saw this picture one bright sunny morning in the autumn while driving through the La Mancha region of Spain. This freshly ploughed field was dotted with small oak trees and the plough had left a ring of grass around each, making them look like little islands.

Thinking

With my penchant for isolated trees, my first thought was to make just one tree the main feature of the image and to exclude the sky, in fact I did so and the result was quite pleasing. However, I looked again at the scene and realised just how much more striking the colour of the ploughed field was if I widened the view to include some of the contrasting blue sky.

Acting

I looked for a viewpoint where this wider view would work comfortably, since I would now need to include at least two trees. From this position I was able to balance the larger foreground tree with a smaller one in the background and this seemed to create a pleasing balance. I used a polarising filter to obtain the maximum colour saturation in the sky and soil and it also made the tiny white cloud more apparent, which added a final touch to the composition.

Technical Details
▼ 35mm SLR camera with a 35–70mm zoom lens, 81A warm-up and neutral-graduated filters with Fuji Velvia.

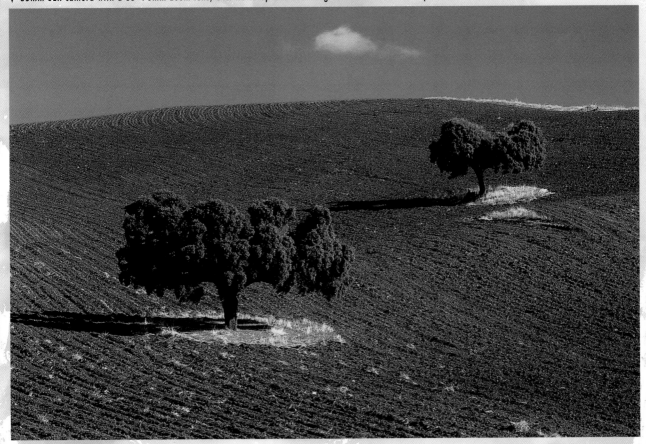

Colour & Composition

2

Colour is a very powerful element in an image. Millions of photographs are taken on colour film every day but very few of these would warrant a second glance. There is a big difference between a photograph which just happens to have been taken in colour and a good colour photograph, this has a great deal to do with the way in which the image is organised. This chapter explains how to be aware of the colour content of an image and how to use viewpoint and framing to create the most telling effect.

Seeing in Colour

One of the main reasons why good colour photographs are not as commonplace as you might imagine from the amount of film which is exposed, is that a great many photographers simply do not look closely enough at their subject. This results in them being not fully aware of the colours it contains and the way they are distributed throughout the image. Taking good colour photographs is really just a question of applying the same thought and care to this aspect of picture taking as you would to choosing clothes or decorating a room.

Seeing

I nearly passed by this scene, in fact, as it was close to my hotel in Venice, I had almost certainly passed by before and the boat with the pink tarpaulin was probably there. But it was the row of washing which made me stop and look. Even then it did not immediately connect that the colour of the fabric at the end of the line was such a close match to that of the boat cover. This made it a must-have picture for me.

Thinking

The only satisfactory viewpoint was from a small bridge, thankfully close to the boat – in fact almost too close. I felt that the strongest composition would be made if I could place the pink fabric in the opposite corner of the frame to the boat cover.

Acting

I found a spot on the bridge where I was able to do this but I was very close to the subject and I needed to use a wide-angle lens to include enough of the boat and all of the washing line with the crucial pink fabric comfortably clear of the edge. I had to wait a while for a large white plastic bag to float past the boat's hull convinced that any second someone would appear to take the washing in, fortunately this did not happen.

Technical Details

▼ 35mm SLR camera with a 100–300mm zoom lens, an 81A warm-up filter and Kodak Ektachrome 100 SW.

This shot was also taken in Venice at a place where the gondolas were parked. They were tightly packed and many were covered with these blue tarpaulins. This image appealed to me because I liked the way the blue fabric creates a frame at the side and base of the image and heightens the impact of the golden coloured wood. I framed very tightly, with a long-focus lens, to emphasise this aspect of the scene and also to create a semi-abstract effect.

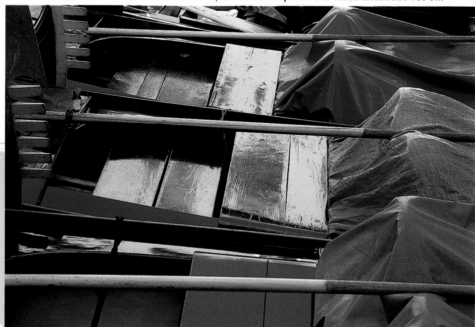

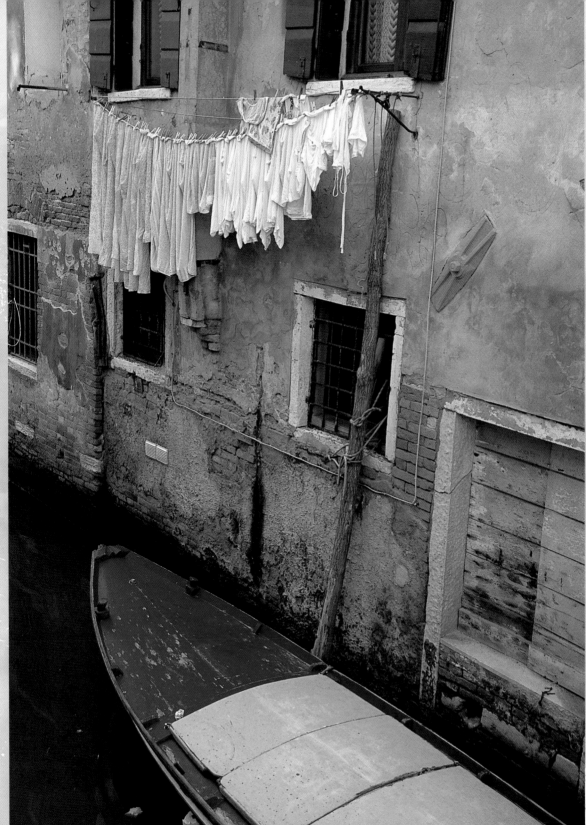

Technical Details
▼ 35mm SLR camera with a 24–85mm zoom lens, an 81A warm-up with Fuji Velvia.

Seeing in Colour

Seeing

It would have been hard to miss this brightly-painted house on Cape Cod, USA, but many of the houses in this region are just as colourful. It was the splendid isolation of this particular building which attracted my attention and the fact that the clear summer sunlight was at a perfect angle from this particular viewpoint.

Thinking

I considered a number of options, the first being to walk to the top of the steps so the green lawn was in the foreground. This would have limited the colour range of the image to just green, red and blue, a fairly restricted colour range is often more effective in a photograph. But I thought the steps were very attractive and would make a good foreground which would also lead the eye towards the house, so I opted for a slightly more distant viewpoint to include them.

Acting

From this position I needed to use a wide-angle lens in order to include the full width of the steps and this meant tilting the camera upwards slightly to include enough sky above the rooftop. This would have caused the sides of the house to converge and spoil the symmetry of the image, which I felt was the picture's strong point, so I used my shift lens to overcome this problem. I used a polarising filter to make the colour of the sky and foliage more saturated and set a small aperture to ensure there was enough depth of field to record both house and foreground steps in sharp focus.

Symmetry again was the quality which appealed to me about this subject, a Dutch farmhouse, as well as its strikingly bold colour, and the fact that the windows suggested a pair of eyes to me. Using a long-focus lens and a tripod-mounted camera I framed the shot very carefully so that there were equal small triangles of blue sky in each corner and the door below the windows was on the central vertical line.

Technical Details
35mm SLR camera with a 70–150mm zoom lens, 81C warm-up and polarising filters with Kodachrome 64.

Technical Details

▼ Medium Format SLR camera with a 50mm shift lens, 81C warm-up and polarising filters with Fuji Velvia.

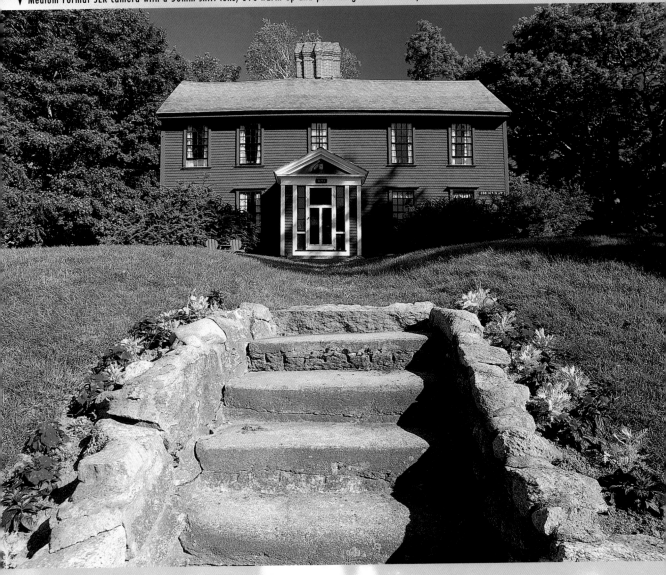

Dominant Colour

Most people are attracted to a colourful scene, one which contains a variety of bright colours. But it is this type of subject from which it is most difficult to produce a satisfying colour photograph. When different parts of the image are vying for attention it is unlikely that the resulting photograph will have a balanced and harmonious quality, or that the main point of the picture will be clearly made. One way of avoiding this problem, and of simplifying the image, is to compose it in such a way that a single colour becomes dominant.

Seeing

I saw this lady Bedouin trader while photographing a camel fair in the Negev Desert in Israel, and was immediately attracted by the bright red yashmak she was wearing, which seemed even more vivid because of the black outer garments which covered the rest of her.

Thinking

I did not want her to be too aware of being photographed, which meant that I was not able to approach her more closely, so I decided to use a more distant viewpoint which meant I had to shoot between the bystanders who surrounded her.

Acting

My first thought was to use the longer setting on my zoom lens and shoot through the gap in the foreground and have a quite close-up image of her. But on reflection I felt that by including an additional area of black on each side of the splash of red it would heighten its effect and also create a more intimate, albeit sneaky feeling to the picture.

The busy fishing harbour of Port Vendres in the Roussillon region of France seems to have developed a wish to have the brightest and most colourful fishing nets in the world, ranging from pastel pink to beige, brown, blue and crimson. They are heaped up on the quay side in piles 4 metres high and I had a very happy 1/2 hour or so there taking many different shots. This was one of the ones I liked best. I framed the image so that it was almost filled with red but with just enough of the black net to create a contrast.

◄ Technical Details
35mm SLR camera with a 24–85mm zoom lens, an 81A warm-up filter and Fuji Velvia.

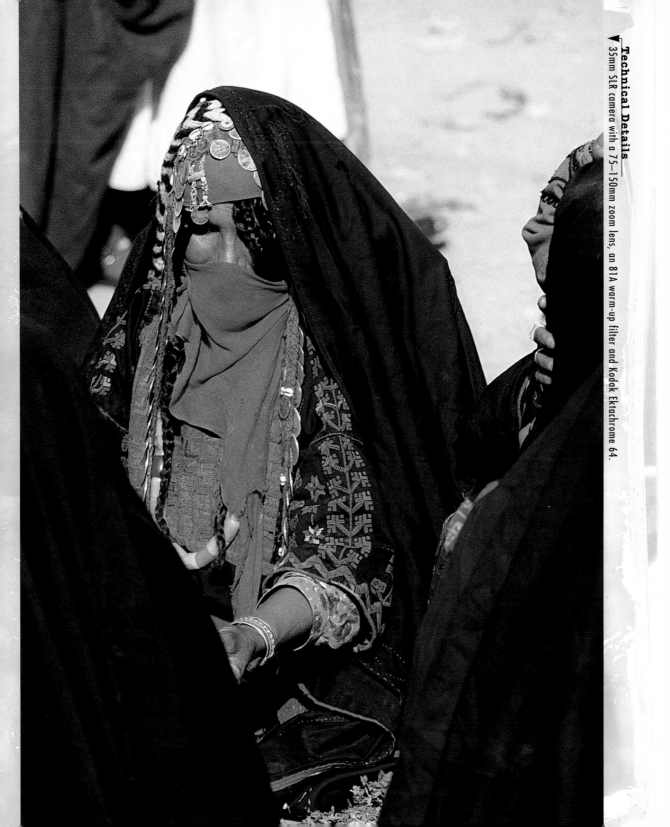

Technical Details
▼ 35mm SLR camera with a 75–150mm zoom lens, an 81A warm-up filter and Kodak Ektachrome 64.

Dominant Colour

Seeing

I spotted this tree-lined track while driving through the Drome region of France. It appealed to me for a number of reasons. Firstly, the track led away from the eye and disappeared into the distance which, to me, gave it something of a fairy-tale atmosphere. Secondly it was unblemished, there were no road signs or markings which would have jarred and the trees were evenly spaced with no broken branches. Thirdly the sunlight was at just the right angle from this viewpoint and created nice dappled highlights without excessively dense shadows. Finally, because the track is fairly neutral in colour the rich green of the foliage became the dominant element.

Thinking

I felt that I wanted to retain the symmetry of the subject and decided to shoot from the centre of the track so that the trees and grass on each side were equal in area and the track disappeared into the centre of the image.

Acting

Having settled on my viewpoint it remained only to decide on how best to frame it. I explored several possibilities using both a wider-angle lens and also with a narrower view from a little further back. I liked this best because, with this framing, the dappled sunlight on the track was contained in the foreground by an unbroken shadow and also because it placed the two foreground trees at the very edge of the image to act like a frame. I used a polarising filter which increased the colour saturation of the foliage significantly.

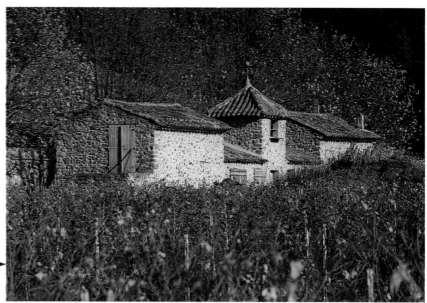

I shot this picture of a farmhouse surrounded by an autumnal vineyard in Provence, France. I liked the rich sepia quality of the foliage and the way in which it was echoed by the ancient roof tiles. The white stone and blue window frames of the building provided an effective element of additional interest but without diminishing the overall colour effect of the image.

Technical Details
35mm SLR camera with a 35–70mm zoom lens, 81C warm-up and polarising filters with Fuji Velvia.

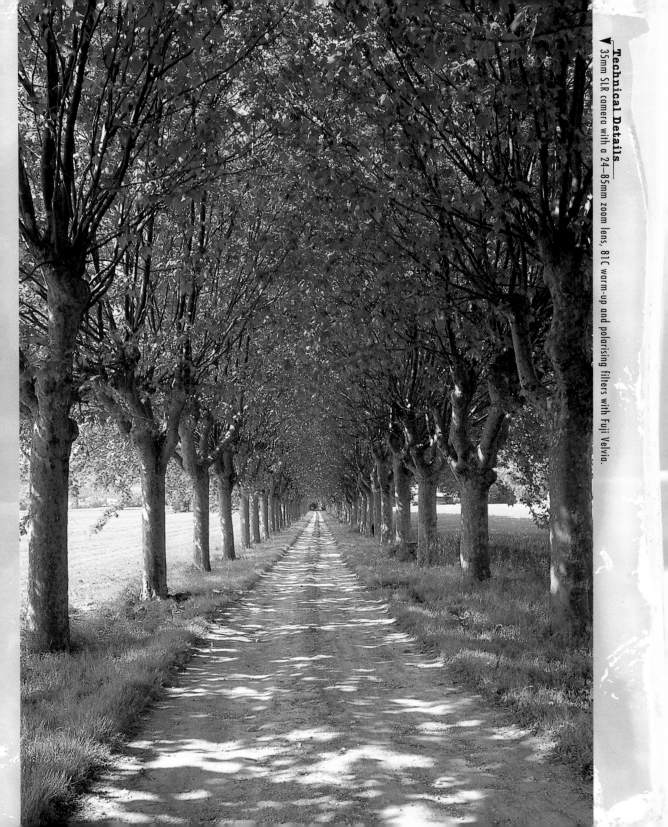

Technical Details
35mm SLR camera with a 24–85mm zoom lens, 81C warm-up and polarising filters with Fuji Velvia.

Dominant Colour

Seeing

The vegetable market in Venice is a marvellous hunting ground for photographers looking for colour pictures, as well as those who like good food. Each stall has carefully arranged displays that would do credit to a still-life photographer and the produce provides a wealth of colour, texture, shape and pattern. These freshly picked artichokes caught my eye because of the soft, subtle colour and also because of the very pleasing shapes and texture of the vegetables.

Thinking

I considered a wider view of the subject which would have shown the artichokes in the context of their setting and also included some other parts of the display but because the colour was so subtle, and because I wanted the picture to have a tactile quality, I decided to move in closer.

Acting

The light was poor and I needed to use a smallish aperture. Using a tripod-mounted camera, I set it as high as I could to give me a birds-eye view of the display and framed the shot so that the best examples of the vegetables filled the frame, and angled the camera in a way which placed the prominent green leaves more or less at the intersection of thirds.

Technical Details
35mm SLR camera with a 24–85mm zoom lens, an 81A warm-up filter and Kodak Ektachrome 100 SW.

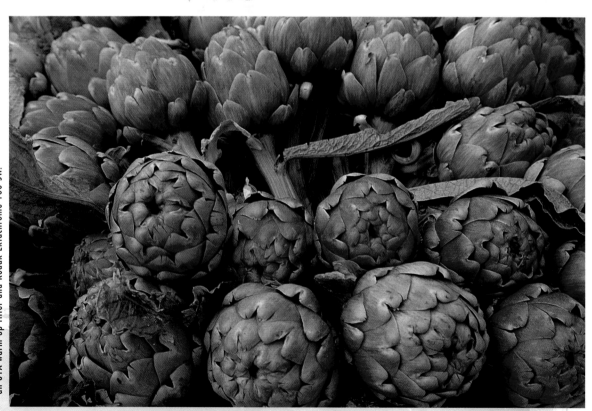

I spotted this picture at a fishermen's café in northern France and was struck by the attractive shade of two-tone green it had been painted. When green occurs in nature it seems pretty unremarkable but in other situations it takes on more importance. The fact that I could see a flash of fisherman's blue through the window completed the composition for me and I framed the shot so this detail was almost in the centre of the image and the green details created a pleasing balance around it.

Colour Contrast

Colour contrast is perhaps the most powerful tool at the colour photographer's disposal in terms of creating visual impact and producing eye-catching pictures. It's most effective when the image contains two dominant colours which are far apart on the spectrum. The strongest contrast is created between the primary and complimentary colours, when yellow is opposed to blue for instance or red to cyan, but even much smaller degrees of contrast can still create a striking effect, especially when the image is restricted to just two colours.

Seeing

On this crystal clear winter's day in the French Alps everything literally sparkled and all the colours seemed ultra-saturated. I had been shooting pictures of skiers coming down the main piste for a while before I became aware of the possibilities which the chair lift offered.

Thinking

I thought that the bright yellow cabin would look very striking indeed against this very pure blue sky, but I needed to isolate the cabin from its other surroundings so the sky was the only other element in the picture. This cabin was going up but other cabins were going down and they were often close to each other. There was also a mountain visible in the background from the spot where I was standing.

Technical Details
35mm SLR camera with a 100–300mm zoom lens, an 81C warm-up filter and Kodak Ektachrome 100 SW.

Technical Details
35mm SLR camera with a 35–70mm zoom lens, an 81A warm-up filter and Kodak Ektachrome 64.

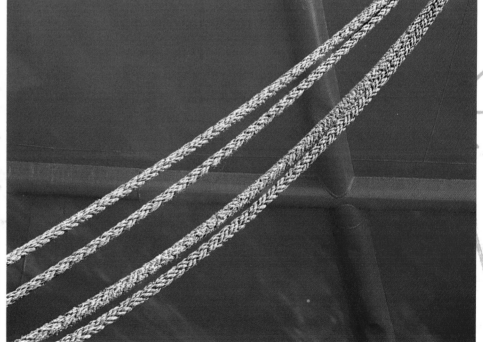

This is about as dominant as colour can become in a photograph but I was attracted as much by the contrast which the graceful loops of white rope had created as I was by the red hull. I framed the shot so the ropes created a diagonal line across the frame but did not go exactly into the top right corner of the image.

Acting

I moved closer to the chair lift, and to one side, which gave greater separation between the up and down cabins and also made the mountain top drop well below the cable. I found that by using a long-focus lens I could frame a single cabin tightly enough to exclude all other details but the cable and the sky. I waited until a nice cabin passed before shooting as some were untidily packed with skis and so on, some contained people wearing unsuitable colours and, in a few, the occupants were staring at me.

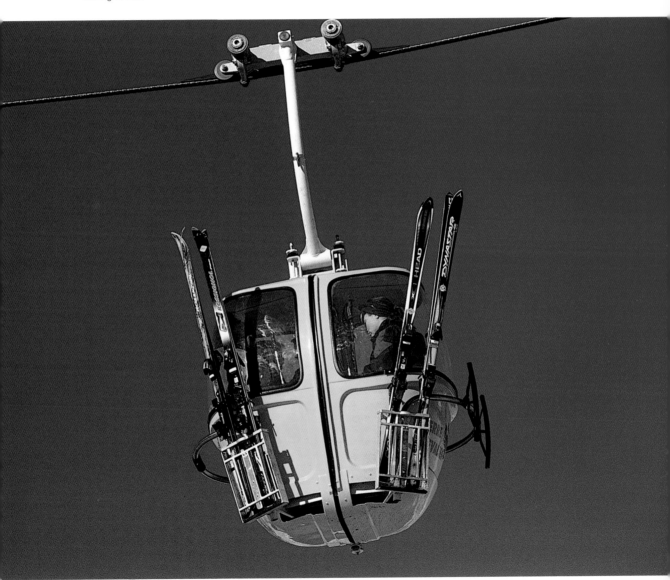

Colour Contrast

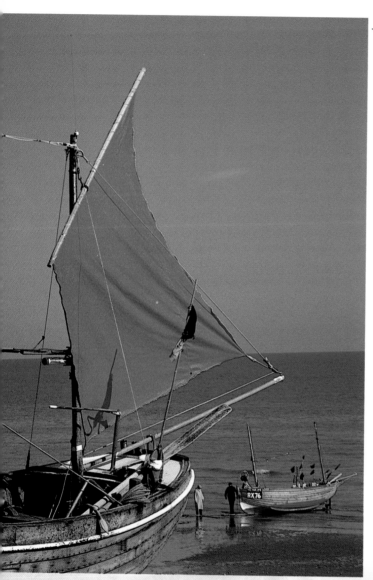

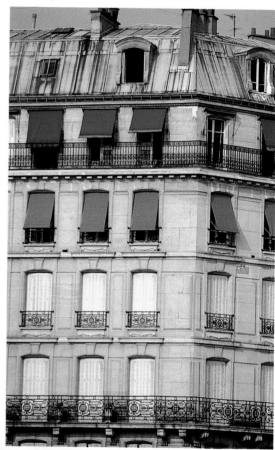

Technical Details
35mm SLR camera with a 35–70mm zoom lens, 81C warm-up
and polarising filters and Kodak Ektachrome 64.

Technical Details
35mm SLR camera with a 75–300mm zoom lens, an 81A
warm-up filter and Kodak Ektachrome 64.

I took this photograph of a fishing boat in the old town of
Hastings in Sussex, UK. It was a bright sunny day with a
strong blue sky and the effect of the red sail against the blue
sea was very striking. I chose a viewpoint which placed the sail
mostly above the horizon and framed the shot so that it fell
more or less on the intersection of thirds.

It was the contrast created by the red blinds in this Parisian
apartment building which caught my eye and although the warm-
coloured stone was not fully opposed to the red the effect is still
quite striking. I framed the shot so that only a small area of sky
was visible and in a way which placed the red blinds along a line
about 1/3 of the way down the picture.

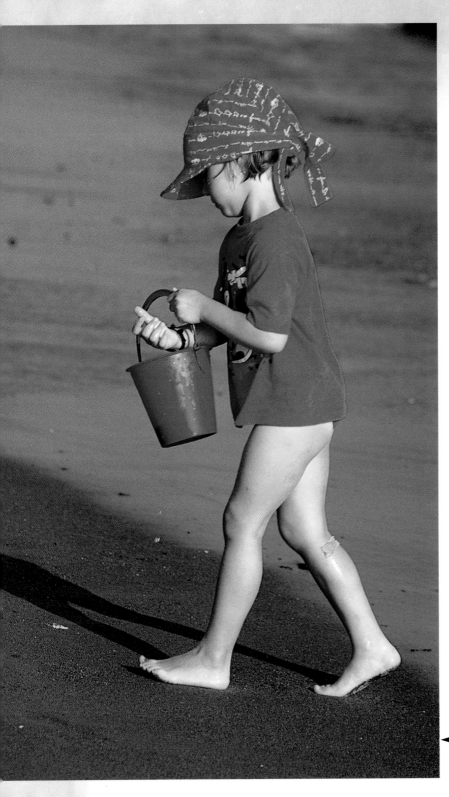

Seeing

I noticed this little girl while taking photographs on a beach in Spain's Costa del Sol and was struck by the powerful **contrast** between her **red** outfit and the deep blue sea. The fact that her bucket was almost the **same shade** of red was a bonus almost more than one dare wish for.

Thinking

I felt it was important to make her the **dominant** feature of the picture, which was not that easy as the beach and sea were **quite crowded** and she was constantly on the move.

Acting

I watched for a while with my camera ready to go and my **patience** was rewarded when she went into a quite clear area of the sea with few people nearby. I waited until she had filled her bucket and started back towards the beach, making my exposure as she took a stride. The **dark** coloured sand along this stretch of coast has helped here as it doesn't introduce another colour. Had it been yellow sand I don't think the effect would have been so **striking**.

◀ Technical Details

35mm SLR camera with a 100–300mm zoom lens and Kodak Ektachrome 100 SW.

Colour Harmony

While using the effect of colour contrast will produce eye-catching images, the more subtle effects are created when the colours in the image are from a similar band in the spectrum and have a more harmonious quality. A sense of mood and atmosphere is more likely to be evoked with this type of photograph, and other visual elements like form and pattern tend to be more effective when the colour palette of the image is less assertive.

Seeing

I came across this deserted house while driving through the Ardeche region of France. I liked the colour and texture of the old stone and the arrangement of weather-worn shutters and shabby green door. It was autumn and the vine leaves had turned to an attractive greeny-gold which blended in really well with the colours of the building. It was a dull, overcast day and the soft light really suited the subject and its mood.

Thinking

I wanted to make the most of the vine and thought that a quite tightly-framed shot would be the best approach. In order to include the top two windows I needed to tilt the camera slightly which caused the verticals to converge and this created a jarring note. The house was close to the edge of a road so I decided to cross to the other side for a more distant viewpoint.

Technical Details
▼ Medium Format SLR camera with a 105–210mm zoom lens, 81C warm-up and polarising filters with Fuji Velvia.

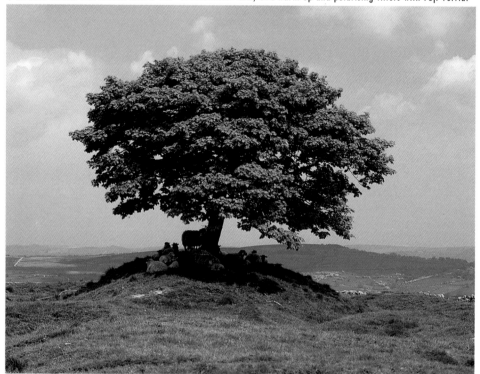

This landscape shot was taken on a hazy day in the countryside of Derbyshire, UK. Although the colours of blue and green are not especially close on the spectrum the soft lighting has made the sky a quite pastel hue which has helped to produce a quite harmonious quality. I framed the shot to give a little space around the tree and in a way which placed it just off centre.

Technical Details

▼ Medium Format SLR camera with a 105–210mm zoom lens, an 81A warm-up filter and Fuji Velvia.

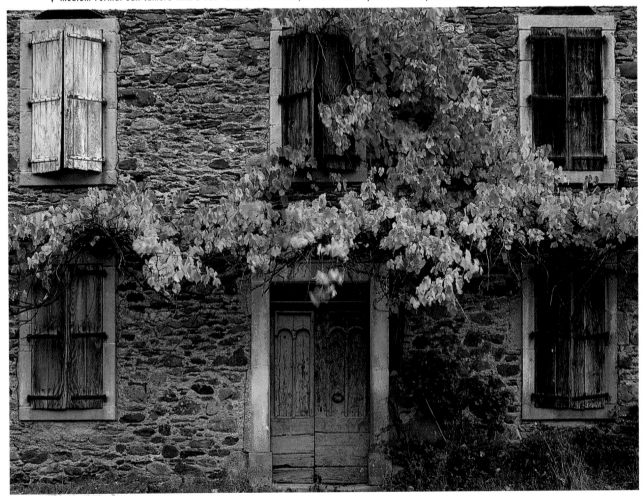

Acting

From here, using a long-focus lens meant the small degree of tilt had little noticeable effect on the parallel lines. I framed the image so that there was just a small strip of stone at the top and sides of the windows to place the door along a central line.

Rule of Thumb

It's best to avoid converging verticals with photographing buildings unless done deliberately for dramatic effect. To do this you must keep the film plane parallel to the building's facade, especially when using a standard or wide-angle lens from a close viewpoint. The use of a shift, or perspective control lens will enable you to move the field of view upwards, or downwards, without tilting the camera.

Colour Harmony

Seeing

These two men were taking a rest in a shady spot in a square in Marrakesh. Because they were in open shade the light was very soft and created very weak shadows.

Thinking

I noticed that although there was an inherent element of contrast between the colours of the pink wall and the man's blue jacket they were essentially soft in quality, and were distributed in a way which seemed to make them blend, making the overall effect of the scene quite harmonious.

Acting

I used a long-focus lens from a fairly distant viewpoint and crouched to place myself at almost their level so their faces were more visible. I framed the image so there was a strip of pink wall on the left of the image and a similar strip of blue door on the right. I then waited until their attention was drawn away from each other and they looked up giving me a better view of their faces.

Technical Details
35mm SLR camera with a 70–200mm zoom lens, an 81A warm-up filter and Kodak Ektachrome 100 SW.

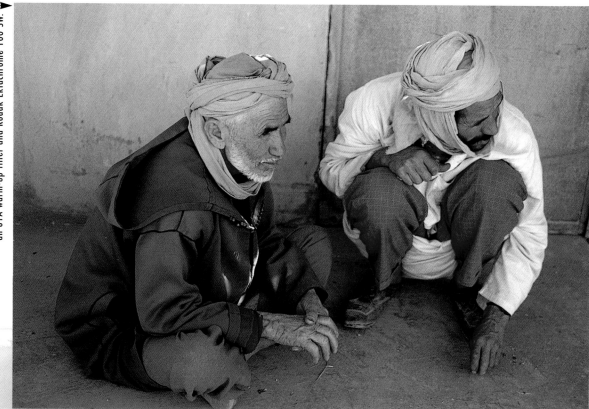

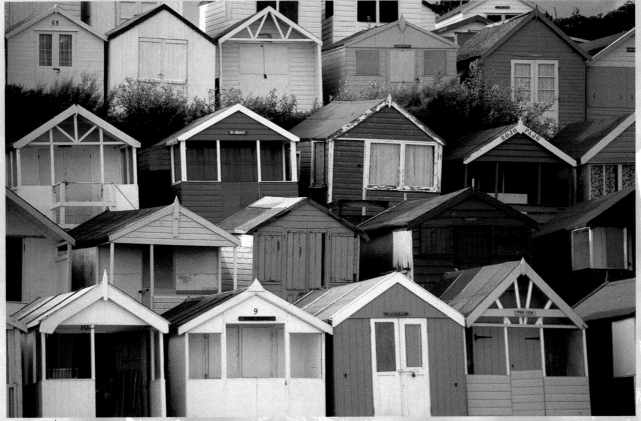

▲ Technical Details

35mm SLR camera with a 75–300mm zoom lens, an 81A warm-up filter and Kodak Ektachrome 64.

This arrangement of beach huts is at Walton-on-the-Naze in Essex, UK, and I was struck by the way that although painted in a variety of colours, the overall effect was quite harmonious. This is partly because they are mostly pale in hue but also because the colours are from a similar band in the spectrum. The other obvious quality of this scene is the strong sense of pattern the similarly-shaped huts have created. I used a long-focus lens to isolate a small area of the scene and to exclude details which contained jarring colours.

The illustration shows how a wider view which introduced different colours would have created a less harmonious effect.

Restricted Colour

It may seem rather odd, but photographs which have a very restricted colour range, indeed almost monochromatic, can also have a quite striking effect. This is partly because most of the colour photographs we see show a wide range of colours and anything which differs from the norm tends to have a more eye-catching quality. Lighting can play an important role in this type of image, the quality of light at dawn and dusk, for example, can subdue even quite bright colours in a scene.

Seeing

On waking early one winter's morning in a hotel in Devon, UK I found the landscape shrouded in a dense fog. But as I drove higher onto Exmoor I realised that it was thinning rapidly and had begun to take on a golden glow as the low-angled sunlight filtered through it.

Thinking

I was desperate to find a feature which I could use as a focus of interest in the image. It had to be something with an interesting shape or outline, as the exposure needed to record colour in the bright sky would almost certainly render foreground details as a silhouette.

Technical Details
35mm SLR camera with a 35–70mm zoom lens, an 81A warm-up filter and Fuji Velvia.

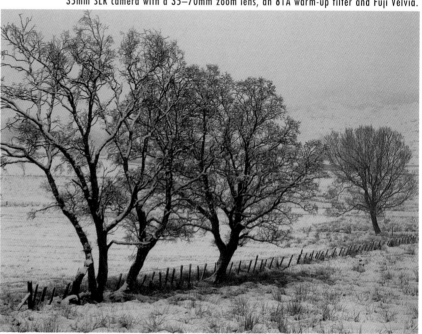

A fresh fall of snow and a very overcast sky created this scene in Cumbria, UK. The two elements which appealed to me were the attractively-shaped trees and the monochromatic quality of the image. I chose a viewpoint which placed the closest tree on the left of the frame with the more distant one on the right and framed the image so that each was on the edge of the picture, actually cropping into the branches of the left-hand tree to balance the composition. I used a weak warm-up filter to prevent the image becoming too blue and gave one stop more than the meter suggested to allow for the brightness of the snow.

Technical Details
Medium Format SLR camera with a 105–210mm zoom lens, an 81A warm-up filter and Fuji Velvia.

Acting

When I saw this small group of trees I thought it might work if the fog thinned just a little more. I set my camera up and **framed the image** so the trees were just to one side of a central vertical line and waited to see what might happen. To my great pleasure the fog suddenly thinned enough to reveal a faint **outline** of a hill in the background but left the trees in bold relief.

Rule of Thumb

In open shade on a sunny day and on overcast days, the colour temperature of the light is higher than that for which the film is balanced and this will produce a blue cast which can be particularly noticeable with subjects like snow scenes. While a warm-up filter can neutralise this cast, in some cases it can be more effective to allow the bluish quality to remain as it emphasises the coldness of the scene.

Restricted Colour

Technical Details
Medium Format SLR camera with a 150mm lens and Kodak Ektachrome 64.

It's much easier to control the colour content of subjects like portraits and still lives particularly when photographed in the studio. I chose a brown background paper for this portrait because I wanted to restrict the colour palette of the image to just different shades of the same hue. The model was lit with a single large, diffused light source placed to one side of him which has created a wide range of tones and I used a white reflector on the opposite side to bounce some light back into the shadows and reduce the contrast.

Technical Details
▼ 35mm SLR camera with a 100–300mm zoom lens, an 81A warm-up filter and Kodak Ektachrome 100 SW.

Seeing

I met this fellow, known as Gerry the Conch man, when he was taking his bucket of conch shells along a beach in Tobago to sell them as souvenirs. He had a **strong face** and I thought he would make an **interesting portrait** and he was quite willing to oblige.

Thinking

It was a bright sunny day and the sea was a **deep blue**, but I wanted to try and produce a picture which was not just a man on a beach with a blue sea as a **background**.

Acting

I asked Gerry if he would sit under one of the straw beach parasols. This solved two problems, it created a much **softer** and more **pleasing light** for his face and the brightness difference between Gerry and the very bright sand and sea background meant that the latter would bleach out, leaving me with an image with a **colour range** of just brown and white. I framed his head tightly using a long-focus lens and asked him to turn his head into **profile** to create a more interesting outline.

Colour & Design

In black and white photography the visual elements of tone, form, line and shape are the factors which determine the composition and effect of an image but although these qualities are still very important in colour photographs they are usually secondary to the colour of objects and details in a subject. The brighter and more saturated the colours are the more dominant they will become, even a tiny area of red, for instance, will attract the eye very strongly in a picture which consists largely of blues and greens. Once you become aware of the way colours can be used to focus attention in this way it can be seen more easily how they can be used to create a sense of design in a picture.

Seeing

I saw this upturned boat on a beach in Kent, UK and was immediately struck by the dominant shape of the hull against the pale-coloured shingle and the bold effect of the red paint.

Thinking

My first thought was to include the whole of the boat in the photograph but when I studied it through the viewfinder I decided that this would include too much of the blue paint which was a very dense colour and I felt it would overwhelm the image.

Acting

By moving in closer and a little higher, I found that the red-painted panel took on an even more interesting shape because of the more pronounced perspective and the intensity of the colour appeared to increase. I framed the shot so that there were just two triangles of blue at the base of the picture with the boat slightly off-centre and a large enough area of shingle above the boat to create a pleasing balance.

Technical Details
▼ 35mm SLR camera with a 35–70mm zoom lens, an 81A warm-up filter and Kodak Ektachrome 64.

Another beach, another boat, with the same colours. In this case I decided to shoot a much more tightly-framed picture in order to produce a more abstract effect. I framed the image so that the area of blue was slightly greater than the red and to place the white band just below the picture's centre.

Technical Details
Medium Format SLR camera with an 80mm lens, an 81A warm-up filter and Kodak Ektachrome 64.

Seeing

This row of vines was being lit by the late afternoon sunlight. It was the contrast between the fresh, green vine leaves and the red soil which interested me but, to begin with, I could not find a satisfactory way of combining these two elements.

Thinking

I realised that if I gave up my initial plan to shoot a pattern picture from a distant viewpoint, I might have more success so I set off along the vine rows looking for a closer viewpoint.

Acting

On doing so I became more aware of the nice dappled light effect which the acutely angled sunlight was creating on the soil and this helped to resolve both my choice of viewpoint and the way I framed the shot. I used a slightly long-focus lens to isolate this small section of the vine row, and framed the image so that the converging path of soil disappeared from view at a point between the centre of the frame and corner. I felt this created a better balance than a completely symmetrical image.

Technical Details

▼ 35mm SLR camera with a 35–70mm zoom lens, an 81A warm-up filter and Kodachrome 64.

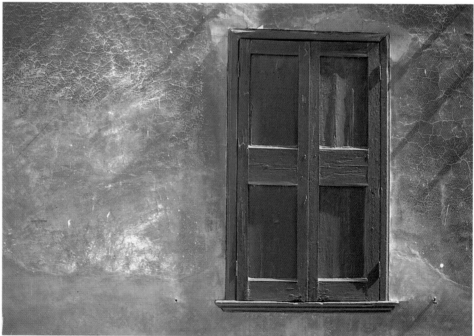

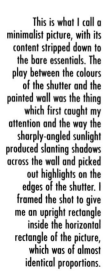

This is what I call a minimalist picture, with its content stripped down to the bare essentials. The play between the colours of the shutter and the painted wall was the thing which first caught my attention and the way the sharply-angled sunlight produced slanting shadows across the wall and picked out highlights on the edges of the shutter. I framed the shot to give me an upright rectangle inside the horizontal rectangle of the picture, which was of almost identical proportions.

▼ **Technical Details**
35mm SLR camera with a 75–150mm zoom lens, an 81A warm-up filter and Kodak Ektachrome 64.

Framing the Image

With subjects such as portraits and still lives a photographer has a great deal of control over both the colour content of a photograph and the way in which the colours are distributed in the image. But when photographing subjects like the landscape, nature or spontaneous shots of people, the only practical way to compose an image is by the choice of viewpoint and the way in which the image is framed. Selection is the key to successful colour photographs and what is left out of the frame can be just as important as what is included.

Seeing

These two photographs were taken in the village of Burano on one of the small islands in the Venetian lagoon. They were in fact taken from the same spot and, apart from altering the angle slightly, the camera was not moved. Several things attracted me to this scene. I noticed first of all the window with the green shutters, the flowers and the line of washing below and it was with this in mind that I began to think about my composition.

Thinking

The house was beside a small canal and the only feasible viewpoint was from the other side, some distance away. For this I needed to use the longest setting on my zoom lens and I made an exposure framing the image so the shuttered window almost touched the sides and top of the frame with only a narrow strip of blue separating them. I then pulled the zoom lens back a little to see if there was a better way of framing this shot.

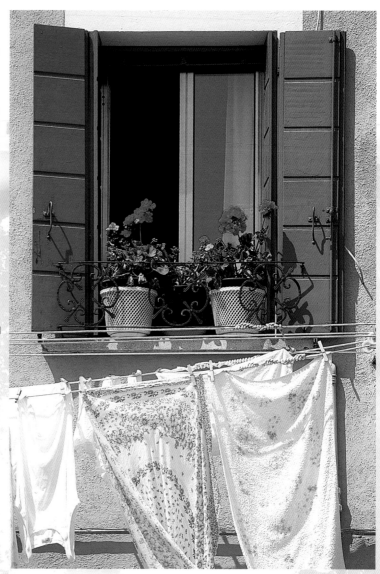

Acting

It was only then that I began to look at the wider view. I realised that I could include some other buildings in the background with a much **wider view** and that by doing so I could incorporate the rather nice **wrought iron** lamp on the corner of the house and a little wider still would include the top of a boat moored beside it. I felt that the image still held together well and had pleasing **balance** and it also said a lot more about the location than the more tightly cropped version.

Rule of Thumb

Very often when you take a photograph of an interesting scene there is more than one shot to be had. Sometimes two or three more selective images of a situation or place can be more telling than just one overall view.

Technical Details

▼ 35mm SLR camera with 100–300mm and 24–85mm zoom lenses, an 81A warm-up filter and Fuji Velvia.

Framing the Image

Seeing

This ochre-coloured house was in a Moroccan village and I stopped to look because of its vivid colour and the way that the acutely-angled sunlight had created a rich textural effect on the adobe wall.

Thinking

First, I thought of shooting the whole structure but it was in a narrow street and the choice of viewpoint was very limited. It was when I began to study the subject a little more closely that I became aware of the possibility of creating rectangular shapes from the segments of wall and using the window as a focus of interest.

Acting

I chose a viewpoint which gave me a front-on view of the wall and then framed the image so the window was more or less on the intersection of thirds in the bottom right segment of the image and the corner of the wall in a similar position in the top left segment.

Technical Details
▼ 35mm SLR camera with a 35–70mm zoom lens, an 81A warm-up filter and Fuji Velvia.

I saw this nice old door and window in a village in the Champagne region of France. I guess because I have a liking for pictures with a strong sense of design, doors and windows often appeal to me. I find the orderly nature of their rectangles strangely satisfying. Pictures like this are often effective when taken front on to the subject and the lack of perspective this produces accentuates the design effect and gives the picture a graphic feel. I framed this shot to include the yellow beam above the window and just a small strip of wall below it.

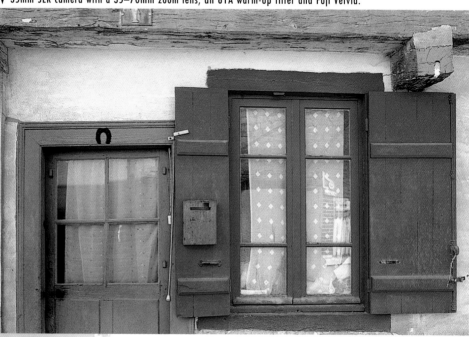

Technical Details

▼ 35mm SLR camera with a 24–85mm zoom lens, an 81A warm-up filter and Fuji Velvia.

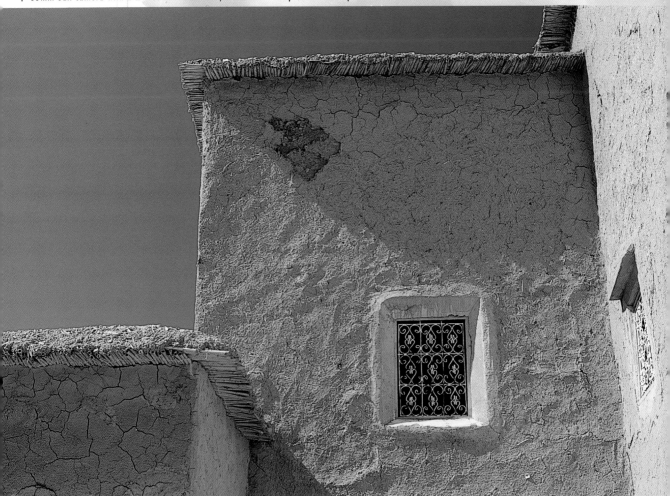

Technique

Perspective can be a powerful element in an image. A lack of it produces photographs with a flat, two-dimensional quality, which can be effective in some circumstances, while shots which accentuate the element of perspective will have a much greater sense of depth and distance. With subjects which have details or objects at different distances from the camera, framing the shot to include close foreground details will heighten the sense of perspective.

Colour & Light

3

Without light normal photography is, of course, not possible. But while the presence of light can make it possible to take a photograph it does not guarantee that the outcome will produce a satisfying image. The quality and direction of light are vital to the success of a picture as it is the interaction between light and the subject which reveals and enhances the visual qualities of shape, form, pattern, texture and colour. The relationship between colour and light is perhaps less easily recognised, look at the pages of a book as you're reading it under bedside light and they will appear white, but they are not; they are orange. This chapter deals with the ways in which you can learn to see the subtle effect which light can have on the colour quality of an image and explains the most effective ways of controlling it.

Colour & Daylight

The majority of photographs are taken in daylight but it can vary enormously in intensity, in its direction and in its quality. To a large extent its intensity is not so important as the use of fast films, a tripod and slow shutter speeds means that acceptable photographs can be taken in very dim light. The direction and quality of the light source is, however, vital to a photograph's success and it is important to be aware of exactly how it affects the subject and to understand how best to use it in order to produce the most telling results.

Technical Details
▼ Medium Format SLR camera with a 55–110 mm zoom lens and Fuji Velvia.

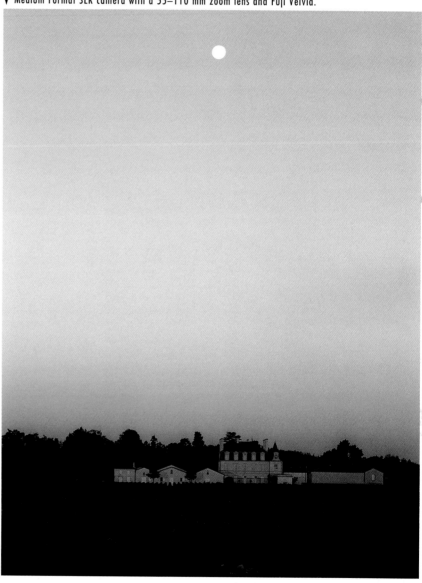

Rule of Thumb

You can learn a great deal about sunlight and how it affects a scene by studying the same location at different times of the day. If I need to photograph a specific location I always try to visit it at the different times especially at the beginning and end of the day.

This building is the chateau of Grand Puy Lacoste, the home of one of the great Pauillac wines in south west France. Shooting pictures for a book on the village, I'd made several trips and spent many weeks there, photographing the chateau in many different lighting conditions. On this occasion, I had risen early to start my journey home and passed the chateau on my way to the autoroute. It was just before sunrise and the light from the eastern sky was illuminating the building, but not strongly enough to outshine the full moon which was nicely placed above the chateau.

Seeing

I took this photograph in the village of Collioure in the Roussillon region of France. It's a place I've visited many times before but although it's very picturesque I've never quite managed to come back with a shot I was really pleased with.

Thinking

On this occasion, it was early spring, and it had been a beautiful day with a clear sky. In fact, I'd taken a few pictures at first light when the sun rises behind the church from this viewpoint. I reasoned, therefore, that the sun at the end of the day might create a nice effect.

Acting

Unfortunately there were some people on the beach and I had limited time because as the sun dropped in the sky both the beach and the church became increasingly in shadow. My final choice of viewpoint was determined by the fact that I needed to hide a couple of people behind the boat but, in any case, a higher viewpoint would have exposed too much shadowed beach.

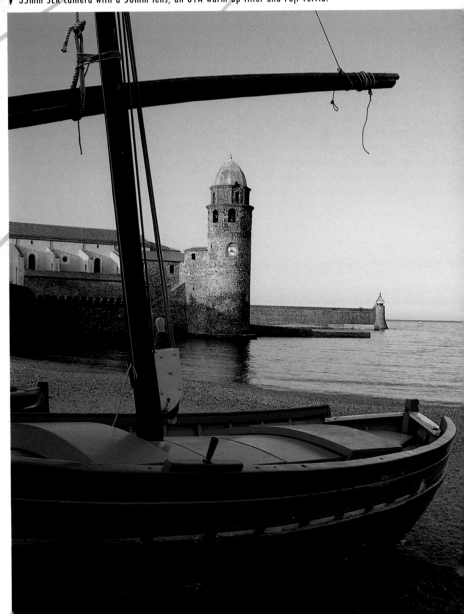

Colour & Daylight

Seeing

I spotted this nice lavender field near the village of Gordes in Provence. It was in full bloom and the plants were mature enough to make unbroken round lines of colour. The sunlight was quite strong although there was some haze in the sky and the overall effect of the scene was quite contrasty.

Thinking

My first thought was to look for an object of detail within the lavender field which could create a focus of interest, like a tree, for instance, or a stone hut – but there was nothing. I then realised that the foreground of bright green vines created a very effective element of contrast, making the colour of the lavender seem even more vivid.

Technical Details
▼ Medium Format SLR camera with a 55–110mm zoom lens, a neutral-graduated filter and Fuji Velvia.

A cloudy sky is usually frowned upon by landscape photographers, unless perhaps it is spectacularly dark and stormy. This shot, taken near my home in the Darent valley in Kent, UK, was lit by very soft sunlight, heavily diffused through a layer of thin cloud, conditions in which I would generally not expect to find myself shooting an open view. But this particular scene appealed to me because of the colour quality of the field of flax in the foreground. The mixture of soft blues and greens seemed to suit the gentle nature of the light and the shadows of the hedgerow trees had just enough bite to prevent the image lacking contrast. I omitted a warm-up filter as I wanted the transparency to have a slight blue cast but I used a neutral-graduated filter to help retain some tone and colour in the sky.

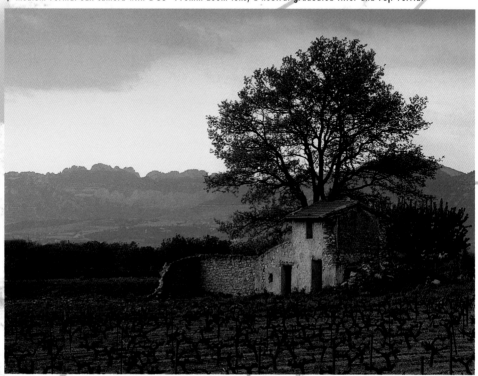

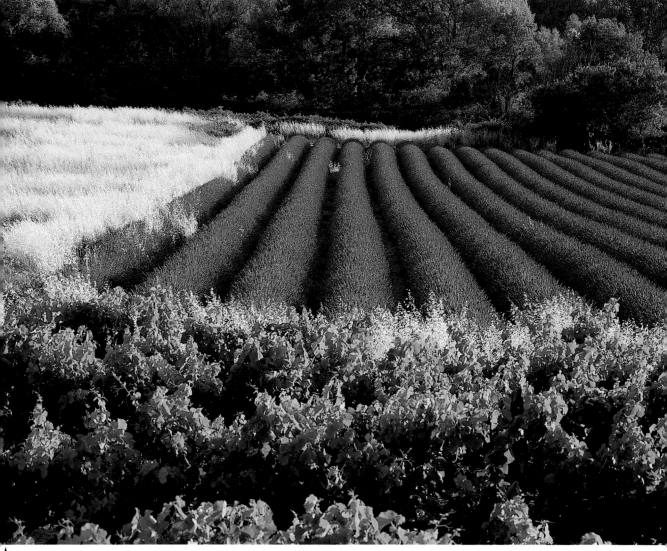

▲ Technical Details
Medium Format SLR camera with a 55–110mm zoom lens, with 81A warm-up and polarising filters with Fuji Velvia.

Acting

I chose a viewpoint which placed the best area of the foreground immediately in front of the camera and framed the shot so that it occupied just over 1/3 of the picture area. I also cropped out the pale sky and angled the camera to include an area of the adjacent field as I thought the white grass would also heighten the impact of the lavender.

Rule of Thumb

It helps a great deal to see and judge lighting effects if you make a habit of looking at shadows. Are they long or short, do they have hard or soft edges, how dense are they and exactly where are they? It's easier to answer these questions if you look at a scene through half-closed eyes, or with the aperture of an SLR camera stopped down.

Colour & Daylight

Seeing

I came across this scene while driving through northern France early one winter's morning and I was struck by the effect which a hard hoar frost had on the landscape. It was very hazy and although the sun was up, and at a low angle, it was heavily diffused and the shadows it cast were almost imperceptible.

Thinking

Although I liked the colour effect of the pastel green and soft brown which the sun and frost had produced I felt the image needed an element of contrast to give it some bite and to give it a focus of interest.

Technical Details
▼ Medium Format SLR camera with a 55–110mm zoom lens, 81A warm-up and neutral-graduated filters with Fuji Velvia.

I saw this scene early one spring evening as I drove through the vineyards in Provence. It had been a cloudy day with very flat lighting and I'd seen almost nothing in the way of a good landscape situation. However, the clouds had begun to clear a little later in the day and I thought there might at least be the possibility of a sunset shot. In many ways I prefer the effect of a partial sunset, like this one, to the more full-blooded variety. I liked the soft and subtle colour in the sky and the effect which the sun, heavily diffused by cloud, created as it glanced off the front of this old stone building. I used a weak warm-up filter to accentuate the colour of the sky and stone and a neutral-graduated filter to retain as much tone and colour in the brightest part of the sky as possible.

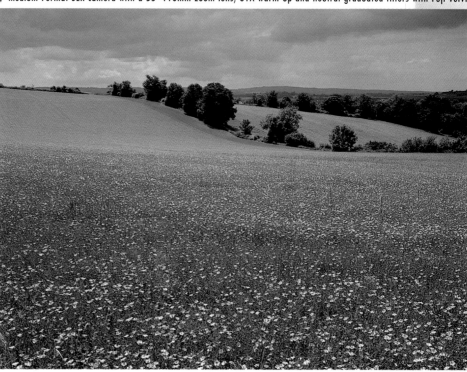

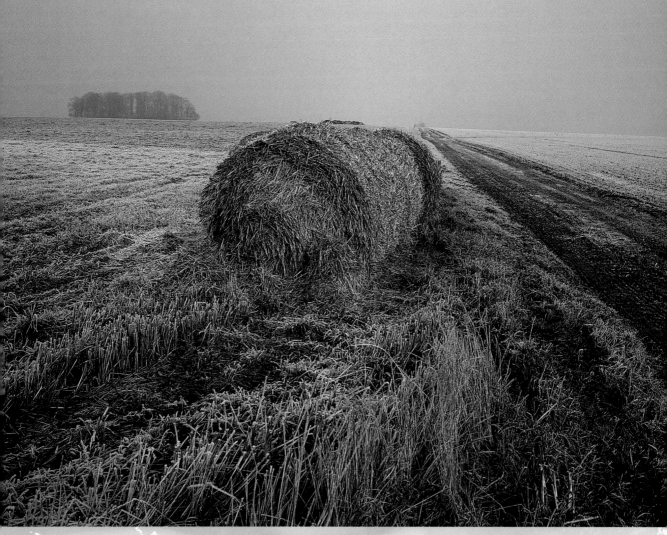

Acting

Finding this bale of hay gave me the extra element I needed. I chose a viewpoint which placed the strands of stubble in the immediate foreground with the hay bale immediately behind. This position also allowed me to have the distant trees just to the left of the hay bale and the track to the right, which seemed to balance the composition very nicely. I then framed the shot to include these basic ingredients.

Technique

The colour of the sky can alter a great deal at different times of the day, and also according to the seasons, and it's often possible to bring this out by just using a neutral-graduated filter. Because the sky is part of the light source an exposure which gives adequate tone and detail in the landscape will cause the sky to be overexposed, and a graduated filter will correct the balance.

Colour & the Time of Day

The position of the sun in the sky is one of the most important factors governing the quality and effect of a photograph. At its highest point, at noon in mid summer, it creates very small shadows and has a colour temperature to which most colour films are balanced. In early morning and late evening the shadows are much longer and the colour temperature of the sunlight is much lower, creating a distinctly warm, orange cast on daylight-type transparency film.

Seeing

This is the chateau of Pichon Longueville in the French village of Pauillac where one of the world's greatest red wines is made. I'd spent a great deal of time in the village shooting pictures for a book. This was the most attractive of all the many chateaux in the vicinity and had been earmarked as the most likely subject for the book's jacket photograph. Consequently, I paid numerous visits to the building in the hope that I would find a particular quality of light which would give the image the edge it needed. The viewpoint was not really negotiable as this front-on angle was the most pleasing.

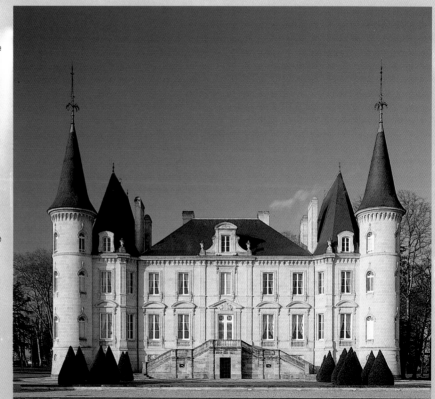

Rule of Thumb

Photographs of buildings invariably benefit from the warmth of late or early sunlight, especially those of stone and brick. Although warmth can be added to the image in the middle of the day by using a strong filter such as an 81EF, it seldom looks completely natural and there's no substitute for the real thing.

Thinking

The building faced east and the sun disappeared from the front around the middle of the day so my best chance was for a sunrise shot. The weather had not been good on any of my visits to Pauillac. My first success was when the sun broke free of the cloud at around eight o'clock on a winter's morning and gave me this image on the left where the sun was low in the sky as well as being sharp and clear. I was pleased with the shot but it did not have the quality which I'd hoped for, the rosy red glow of the sun immediately after it rises.

Acting

But I had a lucky break on my last autumnal visit to the village as, after a sequence of cloudy mornings, on this occasion there wasn't a cloud in the sky just before dawn and I hurried off to the chateau. To my great pleasure the sun rose like a slow-motion rocket from the horizon and for just a few minutes flooded the chateau with this deliciously rich red light. Within a very surprisingly short time however, it lost its colour and the chateau looked very much like the picture I'd taken previously.

Technical Details

▼ Medium Format SLR camera with a 50mm shift lens and Fuji Velvia.

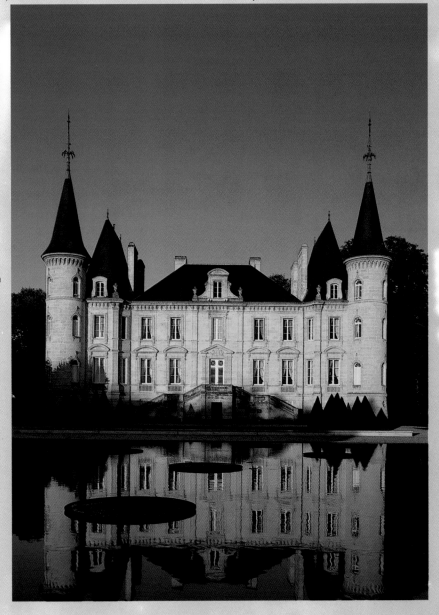

Colour & the Time of Day

Seeing

I saw this scene, near Siena in Tuscany, in the middle of a summer's day when the sun was directly overhead. Many landscape photographers consider this to be a dead time and prefer to shoot early or late in the day when the shadows are longer and the light more mellow. But I've found some of my favourite pictures at this time and overhead summer sunlight frequently does create a sparkling quality and a hot, summery atmosphere which I like.

Thinking

But I was aware that in these conditions the colour temperature of the sunlight would be high and my transparencies would be likely to show a blue cast and look quite cool if I did not take steps to overcome this. I often use a warm-up filter for landscapes and in this case decided to use a fairly strong one, an 81C.

Technical Details
▼ 35mm Viewfinder camera with a 45mm lens, 81C warm-up and polarising filters and Fuji Velvia.

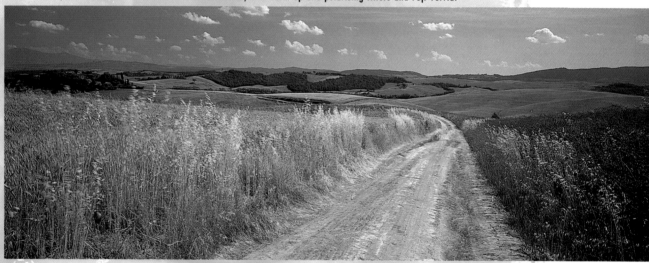

Acting

I thought that I could also help to make the image warmer by including a large area of the golden grasses which lined the track, placing them in the foreground by using a lower viewpoint. With the normal rectangular film format however, I felt too much of the track would be included and also the sky which, apart from a few clouds near the horizon, was a featureless blue. For this reason I opted to use the panoramic shape. I also used a polarising filter to maximise the colour saturation and make the clouds a bit stronger.

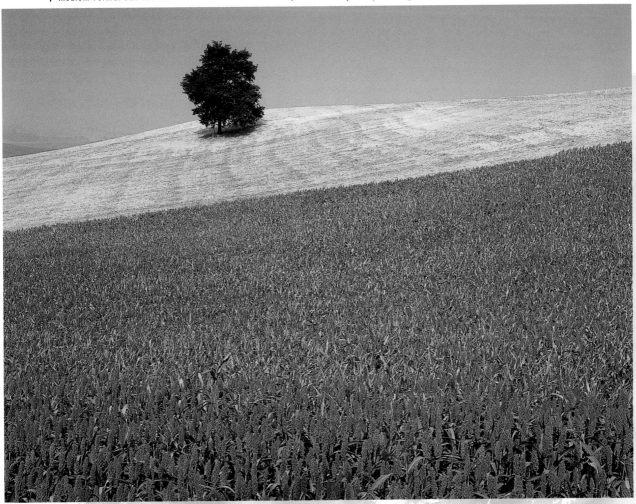

A millet field in the Gascony region of France was the location for this shot. Here too the sun was directly overhead but was diffused slightly by a hazy sky which has created a flatly-lit scene. The warmth and bite of the image comes from the inclusion of the rich brown foreground which was accentuated by the use of warm-up and polarising filters.

Rule of Thumb

When looking for a viewpoint it's worth looking behind you as well as towards your subject as, in this way, you will sometimes find objects or details which can be used effectively as foreground interest.

Colour & the Time of Day

Technical Details

▼ Medium Format SLR camera with a 50mm shift lens and Fuji Velvia.

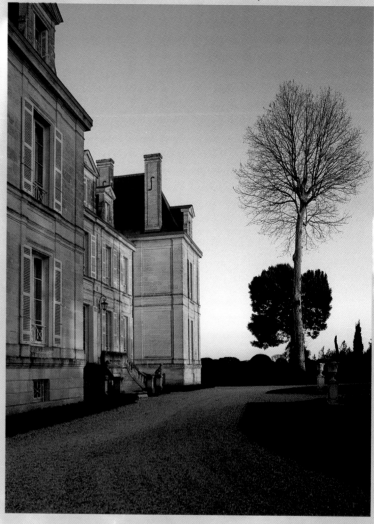

Seeing

This building is the Chateau Comtesse de Lalande in Pauillac, it faces west and is almost opposite Chateau Pichon Longueville (on pages 82-83). Consequently, it needed to be photographed in the afternoon and on this occasion a clear winter's evening sky prompted my visit to the building just before sunset when I was gratified to find the chateau nicely lit with a warm light.

Thinking

I'd photographed the building already from more frontal viewpoints so this time I began to explore other possibilities. I noticed the slender tree which, without its foliage, made a rather elegant shape and I decided to make this a dominant feature of the image.

Acting

From this viewpoint I found that the tree was very clearly silhouetted against the sky and it was also placed in a happy juxtaposition with the chateau. I also liked the fact that from this angle there was a great deal of shadow in the foreground and its bluish colour quality emphasised the warmth of the sunlit stone and also provided an effective dark frame to the main part of the image. I needed to use my wide-angle shift lens in order to obtain enough of the vertical aspect of the building's height to avoid the converging verticals which tilting the camera would have caused.

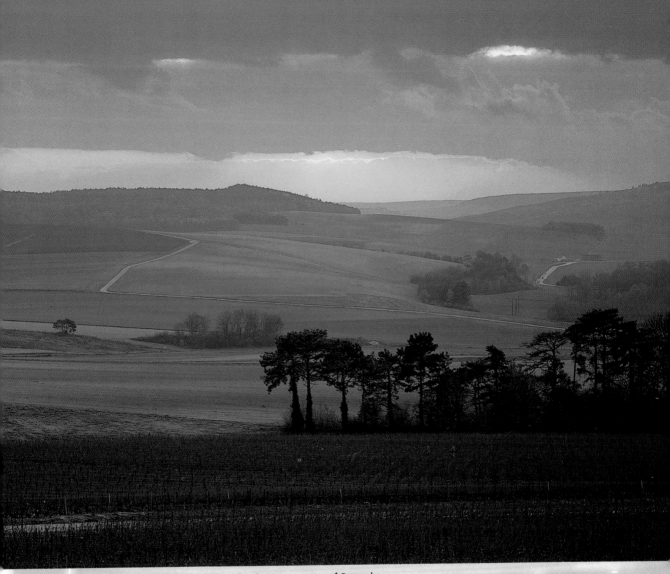

I saw this scene while driving through vineyards in the Champagne region of France late on a winter's day. Again, it was the contrast between the red sky and the bluish quality of the landscape below which attracted me. I used a long-focus lens to frame a relatively small area of the scene and a neutral-graduated filter to enable me to give enough exposure to record tone and detail in the landscape without overexposing the sky.

▲Technical Details
Medium Format SLR camera with a 105–210mm zoom lens, a neutral-graduated filter and Fuji Velvia.

Rule of Thumb

The effect of warm morning or evening light in a photograph is always enhanced if you can include elements of the scene which are in shadow as these areas invariably have a blue quality as a result of being illuminated by the sky, and the contrast accentuates the warmth of the sunlit areas. This is partly why the use of a filter at midday is a poor substitute.

Colour & Mood

Colour can have a very marked effect on our moods. Whether in the home, office or supermarket, much thought is given by interior designers to the way colour can be used in order to trigger a certain subconscious response in people. Similarly, the colour content of a photograph needs to be in harmony with the mood of the scene or subject. A picture of a sombre occasion, for example, would be enhanced if it was dominated by darker hues in the blue-to-purple band of the spectrum but its mood could be greatly diminished if bright yellow or orange details were prominent in the image.

Seeing

I saw this scene late one afternoon while driving through south-west France. I was attracted by the slightly odd clouds in the sky and the way the partially-diffused sunlight had created this very strong highlight on the road surface.

Thinking

Somehow, to me, the scene had a rather bleak quality but I liked the way the bright road snaked into the distance. I realised that shooting into the light meant I would produce an image of high contrast, and to record detail in the road surface would mean underexposing the darker tones of the landscape on each side of it producing little colour. But I thought this would accentuate the slightly sinister mood of the scene.

Technical Details
▼ Medium Format SLR camera with a 55–110mm zoom lens, and Fuji Velvia.

This picture was taken at the Lac du Grand Lieu near Nantes in France. Very still for most of the time and surrounded by reed beds, it's a curious place, with a rather mysterious atmosphere. I was here quite early on a summer's morning and although the sun was shining it was rather hazy so the light was soft which has contributed to the gentle atmosphere of the image. Because most of the image is taken up by the water, which reflects the sky, the overall quality of the image is quite blue which, I feel, enhances the peaceful but slightly melancholy atmosphere of the place.

Acting

I framed the image so that the brightest highlight on the road fell along a line about 1/3 of the way from the edge of the frame with the horizon in the centre. I used a polarising filter to reduce the strength of the highlight on the road and a neutral-graduated filter to reduce the brightness of the sky.

▲ Technical Details

Medium Format SLR camera with a 55–110mm zoom lens, neutral-graduated and polarising filters with Fuji Velvia.

Colour & Mood

Seeing

I saw this peaceful rural scene in Teesdale in Northumbria, UK. It was a very hazy summer's day, not usually the best conditions for landscape photography, but I liked the **atmosphere** which the **soft light** and the green meadow had created.

Thinking

I explored several viewpoints, firstly ignoring the gate as I liked the way the dry stone wall led away into the distance and I had intended to make rather more of the flower-strewn meadow. I was concerned though that there would simply not be enough contrast in the image and it would appear too flat. The combination of overhead sunlight and the haze meant that there were few **dominant** shadows.

The combination of the very bright saturated colour of the sunflower contrasted against the vivid blue sky has not only produced a picture with an eye-catching quality but also an image which is very lively. I chose a very low viewpoint, near ground level, so that I could separate this particular bloom from its surroundings and used a long-focus lens to frame it tightly from a distance, as a closer viewpoint would have distorted the shape of the bloom. I resisted the temptation to use a polarising filter as I thought there was a risk it would make the sky too dark and create excessive contrast.

Technical Details

35mm SLR camera with a 100–300mm zoom lens, an 81A warm-up filter and Fuji Velvia.

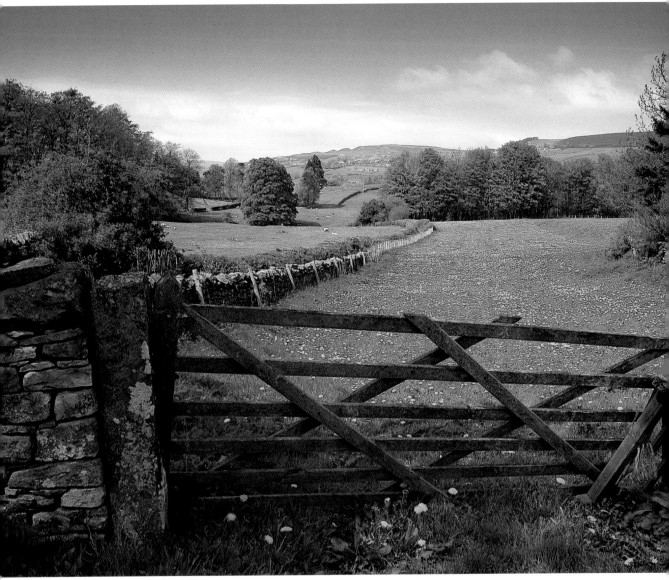

Acting

It was then that I thought of using the gate as foreground interest as by introducing a large area of much darker tones it would boost the overall contrast of the scene quite considerably. I used a wide-angle lens which has enabled me to include most of the gate from a close viewpoint. This has given the image a strong feeling of depth and distance and helped to create a more dynamic composition. I used both a polariser and a neutral-graduated filter to obtain as much tone and colour as possible in the rather weak sky.

▲Technical Details
Medium Format SLR camera with a 55–110mm zoom lens, 81C warm-up, polarising and neutral-graduated filters with Fuji Velvia.

Rule of Thumb

When shooting landscapes in particular the soft light of an overcast day will often produce images with poor contrast and correspondingly weak colour saturation. This can sometimes be overcome by including close foreground details which have either much darker or lighter tones than the remainder of the scene or bright, contrasting colours.

Colour & Artificial Light

Colour film will only reproduce colours which are true to those in the subject when the light source is the same colour temperature for which the film is balanced. An imbalance between the light and the film can be easily corrected by the use of filters but this solution will not solve the problem if more than one light source illuminates the subject and they are of different colour temperatures. There are also situations when the colour temperature of the light source is unknown, such as in street or stadium lighting for example. But the effects created by mixed lighting can be used to produce striking photographs with an interesting and unusual quality.

Technical Details
35mm SLR camera with a 70–200mm zoom lens and Fuji Velvia.

Seeing
I was shooting pictures at dusk in London when I saw this scene in Cambridge Circus and was struck by the vivid colour of the sky and and the colourful reflections in the windows.

Thinking
The foreground had become quite dark as the sky to the east was almost black by now so I looked for a viewpoint which enabled me to exclude as much of the immediate foreground as possible.

Acting
From this position, using a long-focus lens, I was able to isolate the brightest areas of the scene which has helped to keep the contrast to a manageable level.

Rule of Thumb

When shooting on transparency film, it's always wise to bracket your exposures whenever possible, giving 1/2 or 1/3 of a stop more or less than indicated. The colour quality and saturation of the image is very dependent upon exposure and it's not simply a question of setting the correct exposure. Often a degree of under- or overexposure can produce a more effective image than one which is strictly correct and this is especially true when dealing with abnormal lighting conditions.

This oil refinery is on the outskirts of the French port of Marseille. It was a very overcast day and the light had not been very interesting at all until dusk began to fall. But when the plant lighting was switched on it transformed the scene. I chose a viewpoint which created the most pleasing juxtaposition of the chimneys and framed the image using a long-focus lens, to isolate the most interesting section of the scene. I then waited until the sky became dark enough to make the lights appear brighter before making my exposures, bracketing my exposures to about one stop less than indicated and one stop over.

Technical Details
▼ Medium Format SLR camera with a 105–210mm zoom lens, and Fuji Velvia.

Colour & Artificial Light

Seeing

These cellars contain some of the world's most valuable wine, those of the chateau of Lafite Rothschild in Pauillac, France. It's a vast area and the first sight of the space is pretty impressive. To light them using portable lighting would be a task more suited to a large film unit than a humble stills photographer but fortunately the chateau treats these cellars like a piece of theatre and have lit them very effectively for visitors to admire.

Thinking

My problem was that I did not know what sources had been used and what the colour temperature of the lights might be. It also looked to me as if different types of lighting had been used.

Acting

I decided to cover all possibilities and load one of my camera backs with daylight-type film and another with tungsten-type film so I could double up on each shot. For this photograph I chose a viewpoint on a raised area which allowed me to look slightly down on the cellar's main floor and placed a row of barrels in the foreground. I used my widest angle lens and aimed the camera so that the lightest area of the cellar was just off-centre. After processing, I discovered that the tungsten light film had produced a bluish image and the daylight film this warm, almost bronze colour cast, which I preferred.

▲ Technical Details
Medium format SLR camera with a 35mm wide-angle lens and Kodak Ektachrome 100 S.

This shot was also taken at Lafite Rothschild and although it was obvious that the lighting was either tungsten or halogen I decided I would use daylight film deliberately to obtain the warm orange cast which would result because of the imbalance. I felt this would contribute to the picture's atmosphere as the interior of the cellar was essentially grey. I framed the shot to include the dark area surrounding the open door and the candelabra which I hoped would create this starring effect.

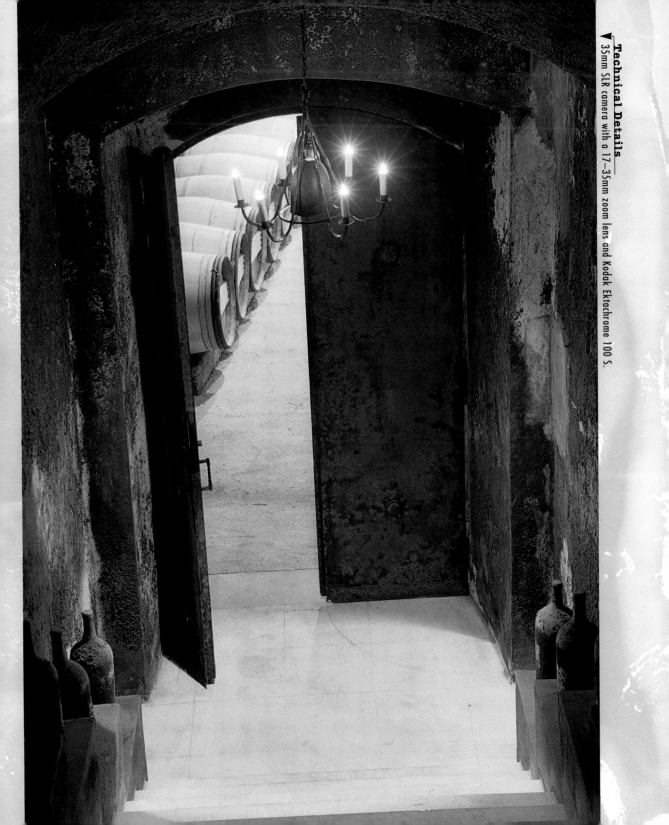

Technical Details
▼ 35mm SLR camera with a 17–35mm zoom lens and Kodak Ektachrome 100 S.

Creating Colour Effects

Most of the time photographers aim to produce pictures which are fairly true to the original scene or subject but there are occasions where it can be interesting and effective to quite deliberately distort and manipulate the colour to produce an abstract or surreal image. There are a number of ways in which this can be done when making colour prints in the darkroom, and of course by computer manipulation, but there are also techniques which can be used in camera, at the time the photograph is taken.

Technical Details
▼ 35mm SLR camera with a 28–70mm zoom lens and Fuji Velvia.

Technical Tip

Deliberately distorted colour can sometimes be very effective. There is a current trend for cross-processing in which colour transparency film is processed as a negative and vice versa but you can also shoot tungsten-type transparency film in daylight and vice versa. Shooting on very fast grainy colour film and then enlarging a small portion of the image is another technique which can be very striking when used with a suitable subject.

The effect of combining movement with long exposures can be very pleasing in colour, subjects like a busy road at night with the car lights creating trails and patterns, for instance. This image is of grape juice being racked into the fermentation tank during wine-making. I simply set a small aperture and gave an exposure of several seconds to record the fast flowing juice as a smoke-like blur.

Seeing

This picture is of the ripples created by swirling water at the edge of a weir. I'd been watching the patterns it made and thought there was an interesting image to be found somewhere in the situation.

Thinking

There was however no colour in the subject as the highlights on the water were white and the shadows black. An ideal subject, I thought, for a black and white image but I had only colour film in my bag.

Acting

I looked in my filter pack and tried a few different ones over the lens to judge the effect and when I fitted this tobacco-tinted filter the image seemed to spring to life. I framed the shot, using a long-focus lens, so that the most striking area of the pattern was emphasised and used a fast shutter speed to freeze the movement of the water.

Technical Details
▼ 35mm SLR camera with a 75–150mm zoom lens, a tobacco-tinted filter and Fuji Velvia.

Creating Colour Effects

Technical Details

▼ 35mm SLR camera with a 100–300mm zoom lens, tricolour filters and Fuji Velvia.

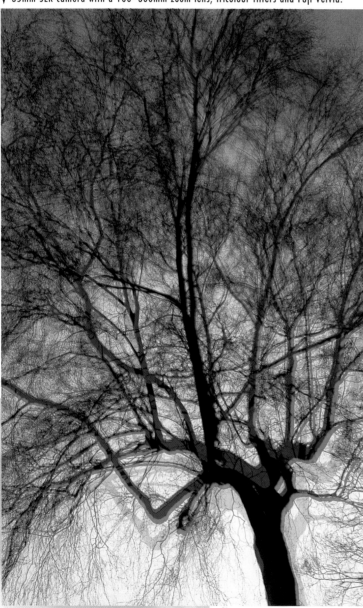

Seeing

There was little or no colour in this scene of a small waterfall but the sunlight was creating brilliant, dancing highlights on the cascading water and I was tempted to have a go at producing a picture from the scene.

Thinking

My first thought was to use a long exposure and a colour filter to obtain an effect similar to the picture on the previous page. But the bright highlights gave me an idea and I thought I'd try an experiment.

Acting

I decided to use the technique described for the previous picture but instead of giving just three exposures, I would give eight onto the same frame of film. To retain the correct colour balance I gave the reading indicated without a filter through the red filter, just once, and then three further exposures at the same setting through the green and four more through the blue. The result is not, perhaps, great art, but an interesting piece of fun.

Colour film is made up of three layers, each sensitive to a different band of the spectrum. By using a set of tricolour filters (red, green, and blue) you can expose each of these layers separately. If the correct exposure is given through each filter onto the same frame of film (using the camera's multi-exposure setting) the end result will be quite normal — unless something has moved when fringes of primary or secondary colour are produced. In the case of this tree I simply moved the camera very slightly in between the exposures but you can try all manner of things — shifting focus, zooming the lens, waiting while clouds move across a landscape between exposures, altering the positions of light in a still life and so on (see technical tip on opposite page).

Technical Tip

To maintain the correct balance through the three tricolour filters you must take a reading without a filter. Give this exposure through the red filter, give 1 1/2 stops more through the green filter and 2 stops more through the blue filter.

I took this photograph of rock formations using Infrared colour transparency film. It's an interesting but very unpredictable film as it is sensitive to both the visible spectrum and the invisible infrared radiation from a subject. Using the recommended filter, a yellow Wratten 12, has produced an image in which the blue sky appears quite normal, but the grey rocks, reflecting different amounts of infrared, are recorded as both blue and magenta.

Technical Details
▲ 35mm SLR camera with a 24–85mm zoom lens, a Wratten 12 filter and Kodak Infrared Ektachrome.

Cameras & Equipment

4

The entire gamut of styles and
photographic techniques can be
drawn upon in the creation of
striking colour photographs, ranging
from life-size images of very small subjects photographed outdoors to studio set-ups,
action pictures and landscapes. In common with all crafts, having the right tools for the
job can make a big difference, both to the ease of working and to the results achieved.
Choosing the right equipment for your particular interests and
understanding how to use it to its full advantage is the first step.

Formats

Image size is the most basic consideration. The image area of a 35mm camera is approximately 24x 36mm but with roll film it can be from 45x60mm up to 90x60mm according to camera choice. The degree of enlargement needed to provide, for example an A4 reproduction is much less for a roll film format than for 35mm and gives a potentially higher image quality.

For most photographers the choice is between 35mm, APS and 120 roll film cameras. APS offers a format slightly smaller than 35mm and for images larger than 6x9cm it is necessary to use a view camera of 5x4in or 10x8in format.

Pros & Cons

APS cameras have a more limited choice of film types and accessories and are designed primarily for the use of colour negative film. 35mm SLR cameras have the widest range of film types and accessories and provide the best compromise between image quality, size, weight and cost of equipment. Both accessories and film costs are significantly more expensive with roll film cameras and the range of lenses and accessories more limited than with 35mm equipment.

View cameras, using sheet film, provide the ultimate in image quality and are particularly suited to subjects such as architecture and still-life photography because the camera movements, such as a tilting lens panel and film plane offer a considerable degree of control over depth of field and subject sharpness. The relatively slow operation of a view camera, and the inability to see the image at the moment of exposure, is, however, a serious drawback with subjects such as people when it can be important to shoot spontaneously.

Technical Details

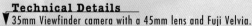

▼ 35mm Viewfinder camera with a 45mm lens and Fuji Velvia.

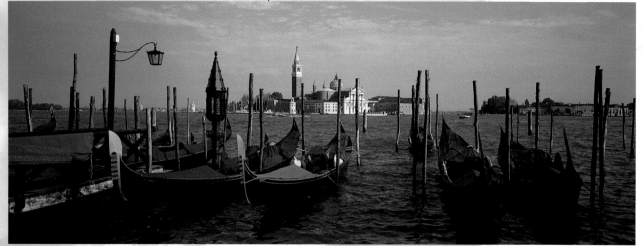

I shot this scene in Burano, Italy on my 35mm SLR, a format ideally suited to this type of subject.

▲ **Technical Details**
35mm SLR camera with a 24–85mm zoom lens, an 81A warm-up filter and Kodak Ektachrome 100 SW.

This shot of Venice was taken on a special panoramic camera but many more simple cameras have an optional panoramic setting, the APS system for instance, which can produce a more pleasing composition from some subjects.

Camera Types

There are two basic choices
between Roll Film, 35mm and
APS cameras; the Viewfinder or Rangefinder Camera and
the Single Lens Reflex, or SLR.

Pros & Cons

An SLR allows you to view through the taking lens and to see the actual image which will be recorded on the film, but the viewfinder camera uses a separate optical system. This can be a major disadvantage with close-up photography in particular as an optical viewfinder becomes increasingly inaccurate as the camera is moved closer to the subject. In addition, the whole image appears in focus when seen through a viewfinder camera but the effect of focussing can be seen on the screen of an SLR making it possible to more accurately judge the depth of field.

Generally, facilities like autofocus and exposure control are more accurate and convenient with SLR cameras and you can see the effect of filters and attachments. SLR cameras have a much wider range of accessories and lenses available to them and are more suited to subjects like wildlife when very long-focus lenses are needed. Viewfinder cameras, such as the Leica or Mamiya 7, tend to be lighter and quieter than their equivalent SLRs but they are not ideally suited to close-up photography because of the limitations of the viewing system.

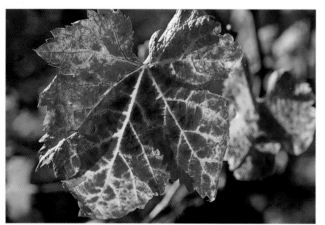

For this close-up of an autumnal vine leaf I used a 35mm SLR camera fitted with a macro lens.

▲**Technical Details**
35mm SLR camera with a 90mm macro lens, and Kodak Ektachrome 100 SW.

The relative sizes of the different camera formats are shown here.

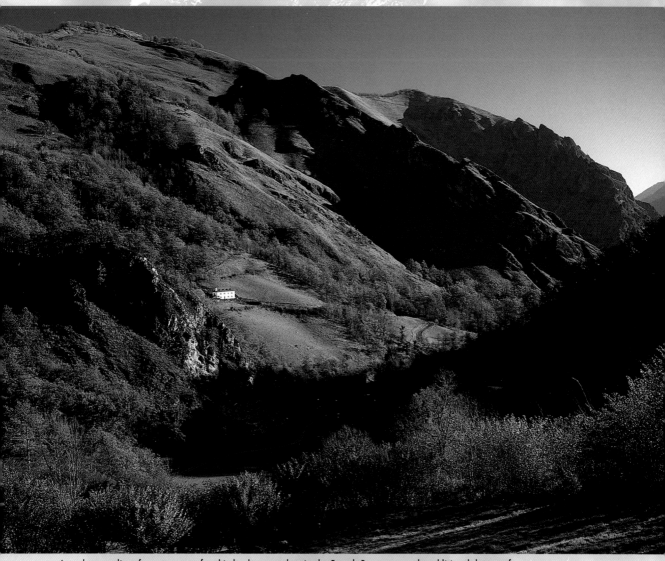

I used my medium-format camera for this landscape, taken in the French Pyrenees, as the additional degree of sharpness and tonal quality of the larger format over 35mm can be an advantage with this type of subject, especially when the image is reproduced very large.

▲ **Technical Details**
Medium Format SLR camera with a 55–110mm zoom lens, 81C warm-up and polarising filters with Fuji Velvia.

A **standard lens** is one which creates a field of view of about 45 degrees and has a focal length equivalent to the diagonal measurement of the film format i.e. **50mm with a 35mm** camera and **80mm with a 6x6cm** camera. Lenses with a shorter focal length create a **wider field** of view and those with a longer focal length produce a narrower field of view. **Zoom lenses** provide a wide range of focal lengths within a single optic, taking up less space and offering more convenience than having **several fixed lenses**.

Pros & Cons

Many ordinary zooms have a maximum aperture of f5.6 or smaller. This can be quite restricting when **fast shutter speeds** are needed in low light levels and a fixed focal-length lens with a **wider maximum aperture of f2.8** or f4 can sometimes be a better choice. **Zoom lenses** are available for most 35mm SLR cameras over a wide range of focal lengths, but it's important to appreciate that the **image quality** will be lower with lenses which are designed to cover more than about a **3:1 ratio**, i.e. 28–85mm or 70–210mm.

Special Lenses

A lens of more than 300mm will seldom be necessary for the majority of photographic subjects but one between **400–600mm** is often necessary to obtain **close-up** images of subjects, such as sports, wild animals and birds.

Extenders can allow you to increase the focal length of an existing lens, a x1.4 extender will make a 200mm lens into 300mm and a x2 extender to 400mm. There will be some **loss of sharpness** with all but the most expensive optics and a **reduction in maximum aperture** of one and two stops respectively.

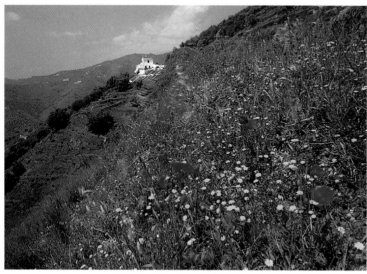

Using a wide-angle lens for this picture, taken in Andalucia, has enabled me to include the flowers in the very close foreground as well as distant details which has heightened the impression of depth and distance. I used a small aperture to obtain maximum depth of field.

▲ Technical Details
35mm SLR camera with a 20mm wide-angle lens, 81C warm-up and polarising filters with Fuji Velvia.

I photographed this early morning vineyard scene, near Macon in France, using a long-focus lens. This has allowed me to isolate a small area of the scene and also give the impression of compressed perspective.

Technical Details ➤
Medium Format SLR camera with a 105–210mm zoom lens, an 81B warm-up filter and Fuji Velvia.

Camera Accessories

There are a wide range of accessories which can be used to control the image and increase the camera's capability.

Technique

A soft-focus filter can be effective in some circumstances to reduce contrast and colour saturation and help create a more romantic mood for subjects such as portraits and landscapes.

Perhaps one of the most important accessories for good colour photography is a tripod as it can greatly improve image sharpness. The effects of camera shake are much more noticeable when the subject is close-to. Small apertures are often needed to create sufficient depth of field and a tripod allows slower shutter speeds to be used without a risk.

A tripod should be considered obligatory whenever it is possible to use one as it enables you to aim, frame and focus the camera on your subject with the knowledge that it will remain accurately positioned. This allows you to concentrate more on matters like composition and lighting.

Extension tubes, bellows units and dioptre lenses will all allow the lens to be focussed at a closer distance than it's designed for.

A selection of filters will help to extend the degree of control over the colour quality of an image and a square filter system, such as Cokin or HiTech, is by far the most convenient and practical option. These allow the same filters to be used with all your lenses regardless of the size of the lens mounts as each can be fitted with an adaptor upon which the filter holder itself can be easily slipped on and off.

A Polarising filter is extremely useful for reducing the brightness of reflections in non-metallic surfaces, such as foliage, and will also make a blue sky record as a richer blue creating greater relief with white clouds.

Polarisers are available in either linear or circular form. The former can interfere with some auto focussing and exposure systems, as your camera's instruction book should tell you, but if in doubt use a circular polariser.

Technique

A Polaroid back can be bought to fit many professional 35mm cameras such as the Canon EOS1N and the Mamiya 645. These can be extremely useful when using flash lighting as the exact effect of the set-up can be seen before the image is exposed onto normal film.

I took this photograph some time after sunset, on Spain's Costa del Sol, by which time it was getting quite dark. I needed an exposure of around 1 second which made the use of a tripod essential.

▲ Technical Details
35mm SLR camera with a 100–300mm zoom lens and Fuji Velvia.

This diagram shows a bellows unit fitted between the camera body and lens.

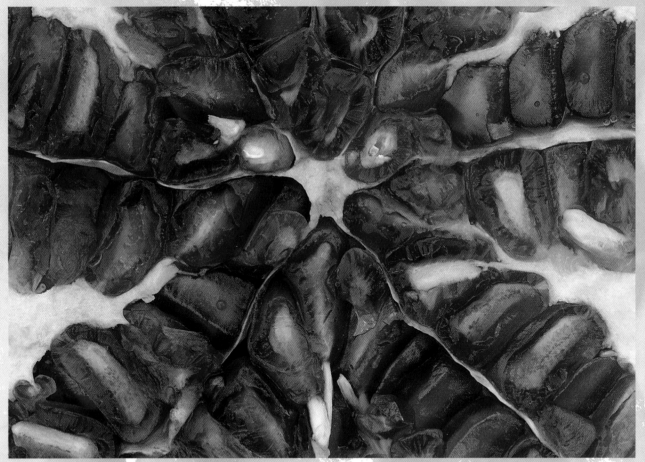

A photograph like this, an almost life-size image of pomegranate seeds, needs an extension tube or bellows unit to enable a normal lens to focus at a close enough distance.

▲ **Technical Details**
35mm SLR camera with a 24–85mm zoom lens, an extension tube and Fuji Velvia.

Understanding Colour

A basic knowledge of the principles upon which colour film works can be a considerable aid in controlling the colour quality of a photograph as well as helping to identify errors and avoiding disappointing results.

Colour film has three separate layers, each sensitive to a particular band of the visible spectrum. If a beam of light made up from each of the primary colours, red, green and blue, is projected with equal intensity onto a white surface, white will be shown where all three colours overlap. Where just the blue and red light overlap the secondary colour of magenta is created and where just the blue and green light are mixed together cyan is produced. The mixture of red and green light produces yellow, the third of the secondary, or complimentary colours. All of the in-between hues of the visible spectrum are created when the intensity of the three coloured lights varies. The film's emulsion works in the same way, each layer of the film recording a different level of density according to the make up of the colours being photographed.

In a similar way, the secondary or complimentary colours mix to recreate the primary colours and this is the principle upon which colour printing works. Cyan and magenta when mixed as dyes or inks will create blue, cyan and yellow will produce green while yellow and magenta will create red.

A colour transparency film goes through two stages during processing. Firstly, a negative image of the subject is created in which both the tones and colours are reversed so that a white detail in the subject is recorded as black and a red one as cyan, etc. During the process however, without being seen, the image is changed back to a positive in which the tones and colours closely resemble those of the subject.

With colour negative film this process takes place in two separate stages. The first stage is a negative image with tones and colours reversed. However, the colours in a negative film are not readily identifiable because a special correction layer, with an orange tint, is included in the emulsion to rectify shortcomings in the films dyes. When a colour print is made, the tones and colours are reversed back to those in the original subject.

This explains the apparent anomaly that when you wish to add red to an image shot on transparency film you must use a red filter but if you wish to add red when printing from a colour negative you need to use a cyan filter.

It's also important to appreciate that colour transparency film is designed to give accurate colours when exposed to a light of a specific colour temperature. When shooting in tungsten light, for example, which has a much lower colour temperature than daylight, you must either use film balanced for use in tungsten light, or use a colour correction filter, in order to avoid an orange colour cast. In the same way, a photograph taken in daylight using a film balanced for tungsten light will produce an image with a strong blue cast.

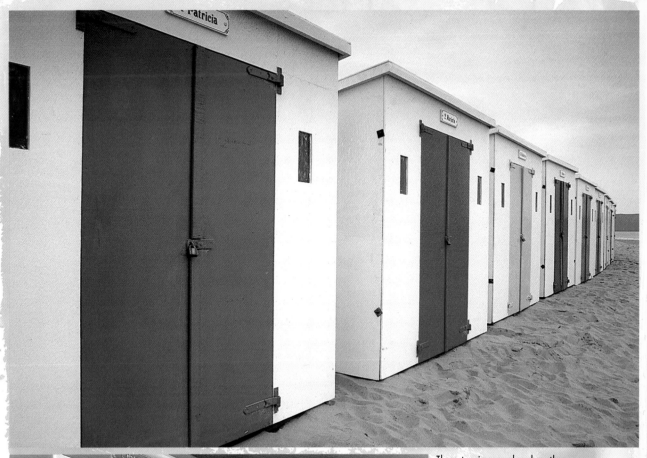

These two images show how the colours as well as the tones are reversed in the negative. In this way green in the positive becomes magenta in the negative and red becomes cyan.

▲ Technical Details

35mm SLR camera with a 24–85mm zoom lens, an 81A warm-up filter and Fuji Velvia.

Understanding Exposure

Modern cameras with automatic exposure systems have
made some aspects of achieving good quality images
much easier but no system is infallible and an understanding of how
exposure meters work will help to ensure a higher success rate.

An **exposure meter**, whether it's a built in TTL (through-the-lens) meter or a separate hand meter works on the principle that the subject it is aimed at is a mid tone, known as an **18% grey**. In practice, of course, the subject is invariably a **mixture of tones and colours** but the assumption is still that, if mixed together, like so many pots of different-coloured paints, the resulting blend would still be the same 18% grey tone.

With most subjects the reading taken from the whole of the **subject** will produce a satisfactory exposure. But if there are aspects of a subject which are abnormal, when it contains large areas of **very light** or **dark tones**, for example, the reading needs to be modified.

An exposure reading from a snow scene for instance would, if uncorrected, record the white snow as **grey** on film. In the same way a reading taken from a very dark subject would result in the image being **too light**.

The exposure needs to be **decreased** when the subject is essentially dark in tone or when there are large **areas of shadow** close to the camera. With abnormal subjects it is often possible to take a close-up or **spot reading** from an area which is of normal, average tone.

Many cameras allow you to take a spot reading from a small area of a scene as well as an average reading and this can be useful for calculating the exposure with subjects of an **abnormal tonal** range or of high contrast. Switching between the average and spot reading modes is also a good way of **checking** if you are concerned about a potential exposure error. If there is a difference of more than about 1/2 a stop, when using transparency film, you need to consider the scene more carefully to decide if a degree of **exposure compensation** is required.

Technical Details

▼ 35mm SLR Camera, 24–85mm zoom lens, 81C warm-up and polarising filters with Fuji Velvia.

These landscape pictures show the effect of bracketing exposures, the central image received the exposure indicated by the meter while the two darker frames had 1/3 and 2/3 of a stop less and the two lighter frames had 1/3 and 2/3 of a stop more.

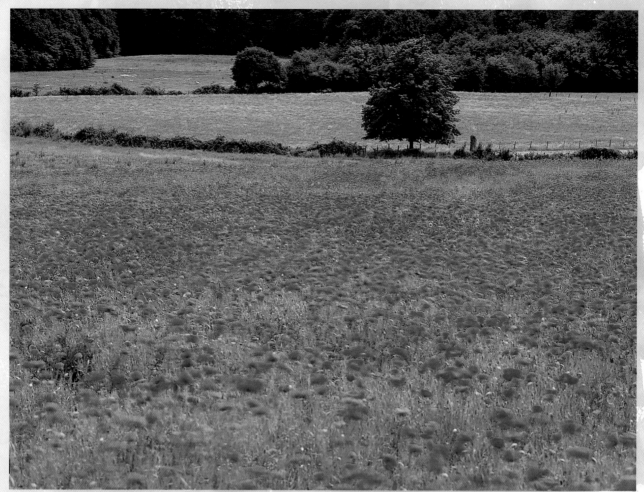

I photographed this poppy field in the Loire region of France. Being a subject of normal tonal range and contrast
the camera's exposure meter gave me an accurate reading which needed no compensation.

▲ Technical Details

Medium Format SLR camera with a 105–210mm zoom lens, 81C warm-up and polarising filters with Fuji Velvia.

Understanding Exposure

With negative films there is a latitude of one stop or more each way and small variations in exposure errors will not be important, but with transparency film even a slight variation will make a significant difference to both the image quality and the colour saturation, where possible. It's best to bracket exposures giving a 1/3 or 1/2 a stop more and less than indicated, even with normal subjects.

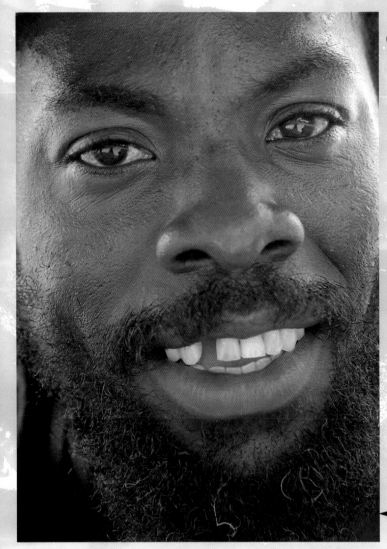

Technique

Clip testing is an effective way of overcoming this problem. For this technique you need to establish your exposure and shoot a complete roll at the same setting, assuming the lighting conditions remain the same. You need to allow two frames at the end of the roll in the case of roll film, or shoot three frames at the beginning of a 35mm film, which you must ask the processing laboratory to cut off and process normally. The exposure can then be judged and the processing time of the remainder of the film adjusted to make the balance of the transparencies lighter or darker if necessary. Increasing the effective speed of the film, known as pushing, and making the transparency lighter, is more effective than reducing the film speed, known as pulling, to make the image darker. For this reason it is best to set your exposure slightly less than calculated if in any doubt.

Exposure compensation can also be used to alter the quality and effect of an image, especially with transparency film. When a lighter or darker image is required this can be adjusted at the printing stage when shooting on negative film but with transparency film it must be done at the time the film is exposed.

I gave 1/2 a stop less than the meter indicated for this portrait as otherwise his dark brown skin would have recorded as too light a tone.

Technical Details
35mm SLR camera with a 100–300mm zoom lens, an 81A warm-up filter and Kodak Ektachrome 100 SW.

Technical Details

▼ 35mm SLR camera with a 100–300 zoom lens, an 81B warm-up filter and Kodak Ektachrome 100 SW.

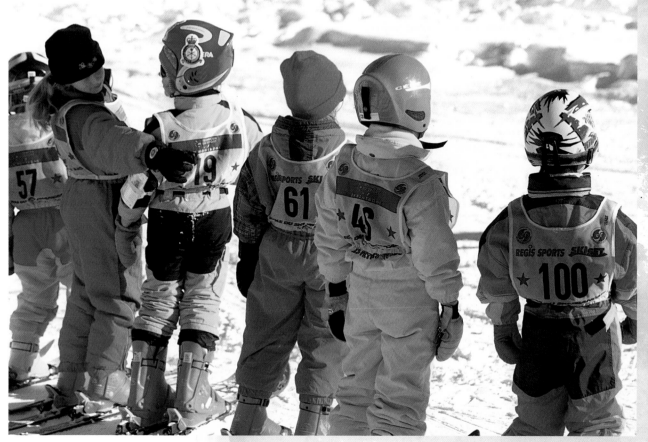

For this shot of young skiers I gave 2/3 of a stop more exposure than was indicated to compensate for the very bright snow in the background.

Rule of Thumb

Although bracketing is effective when dealing with a completely static subject like a landscape or still life it's not always the best solution when taking photographs in situations where the subject is moving, such as when photographing people or animals for example. Even a slight change in the expression or posture can make one frame much better than the next and in a bracket this might not be the best exposure.

Apertures & Shutter Speeds

The aperture is the device which controls the brightness of the image falling upon the film and is indicated by f stop numbers f2, f2.8, f4, f5.6, f8, f11, f16, f22 and f32. Each step down, from f2.8 to f4 for example, reduces the amount of light reaching the film by 50% and each step up, from f8 to f5.6 for instance, doubles the brightness of the image.

The shutter speed settings control the length of times for which the image is allowed to play on the film and, in conjunction with the aperture, control the exposure and quality of the image.

Technical Details

▼ 35mm SLR camera with a 24–85mm zoom lens, 81C warm-up and polarising filters with Fuji Velvia.

For this scene, photographed in the Umbria region of Italy, I set a small aperture to ensure that the image was as sharp as possible from the closest to the furthest details.

Choice of aperture also influences the depth of field, which is the distance in front and beyond the point at which the lens is focussed. At wide apertures, like f2.8, the depth of field is quite limited making closer and more distant details appear distinctly out of focus. The effect becomes more pronounced as the focal length of the lens increases and as the focussing distance decreases so with, for example a 200mm lens focussed at one metre and an aperture of f2.8 the range of sharp focus will extend only a very short distance in front and behind the subject. The depth of field increases when a smaller aperture is used and when using a short focal length, or wider-angle lens. A camera with a depth of field preview button will allow you to judge the depth of field in the viewfinder.

Technical

The choice of shutter speed determines the degree of sharpness with which a moving subject will be recorded. With a fast-moving subject, like an animal running or a bird flying for instance, a shutter speed of 1/1000 sec or less will be needed to obtain a sharp image.

The choice of shutter speed can also affect the image sharpness of a static subject when the camera is hand-held as even slight camera shake can easily cause the image to be blurred. The effect is more pronounced with long-focus lenses and when shooting close-ups. The safest minimum shutter speed should be considered as a reciprocal of the focal length of the lens being used, 1/200 sec with a 200mm lens, for instance.

Technical Details
▼ 35mm SLR camera with a 35–70mm zoom lens, 81C warm-up and polarising filters with Fuji Velvia.

I used a shutter speed of about 3 seconds to record the moving water as a soft smoke-like blur in this photograph, taken in the Spanish Pyrenees. A tripod was essential to ensure that the static elements of the image remained sharp.

Choosing Film

There is a huge variety of film types and speeds from which to choose and although, to a degree, it is dependent on personal taste there are some basic considerations to be made. Unless you wish to achieve special effects through the use of film grain it is generally best to choose a slow, fine-grained film for most colour photography if the subject and lighting conditions will permit.

Technical

Many films are now produced to suit **different subjects** such as portraits and landscapes. A warm, strongly **saturated** film such as Fuji Velvia is ideal for **landscapes** for example but does not produce very flattering skin tones.

Technical

For special effects, Kodak's **Infra-Red Ektachrome** can be a fascinating material to experiment with. It records both visible light as well as the invisible Infra Red and this element can produce very **unpredictable** results. Because the infra-red light cannot be measured by an exposure meter there is a large element of guess work involved. As a basis, the film is recommended to be rated at ISO 100 but it is wise to **bracket** widely, at least a stop each side. The best results are likely to be obtained using the recommended **Wratten 12 yellow filter** but other filters can produce interesting effects with certain subjects.

Rule of Thumb

The choice between colour negative film and transparency film depends partly upon the intended use of the photographs. For book and magazine reproduction transparency film is universally preferred and transparencies are also demanded by most photo libraries. And, of course, transparency film is necessary for slide presentations. For personal use, and when colour prints are the main requirement, colour negative film can be a better choice since it has greater exposure latitude and is capable of producing high quality prints at a lower cost. With all film types, its speed determines the basic image quality. A slow film of ISO 50, for instance, has finer grain and produces a significantly sharper image than a fast film of ISO 800. The accuracy and saturation of the colours will also be superior when using films with a lower ISO rating.

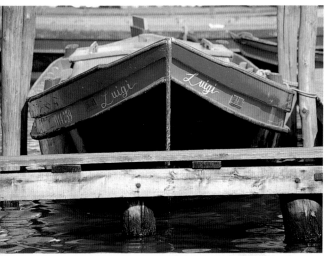

I used Kodak Ektachrome 100 VS (very saturated) for this shot, taken in Venice on a very dull day, in order to accentuate the rich colours of the boat.

▲Technical Details
35mm SLR camera with a 100–300mm zoom lens, an 81A warm-up filter and Kodak Ektachrome 100 VS.

For this portrait of a French vigneron I used Fuji Provia for its ability to record skin tones well.

Technical Details▶
35mm SLR camera with a 70–200mm zoom lens, an 81A warm-up filter and Fuji Provia.

Using Filters

Even in the best conditions, filters are often necessary, especially when shooting on transparency film. It's important to appreciate that colour transparency film is manufactured to give correct colour balance only in conditions when the light source is of a specific colour temperature. Daylight colour film is balanced to give accurate colours at around 5,600 degrees Kelvin but daylight can vary from only about 3,500 degrees K close to sundown to nearly 20,000 degrees K in open shade when there is a blue sky.

The effect of an imbalance between the colour temperature of the light source and that for which the film is balanced can be very noticeable. The blue tint for example, when shooting in open shade can be quite marked and in these situations a warm-up filter, such as an 81A or B is needed. In late afternoon the sunlight can be excessively warm for some subjects and then a blue-tinted filter such as an 82A or B is needed.

A polarising filter can be very useful for increasing the colour saturation of details such as foliage and for making the sky or sea a richer colour. It is equally effective when used with colour print film, whereas the qualities created by colour balancing filters can easily be achieved when making colour prints from negatives.

A polariser can also help to subdue excessively bright highlights when shooting into the light, like the sparkle on rippled water. Polarisers need between one and a half and two stops extra exposure but this will automatically be allowed for when using TTL metering.

Neutral-graduated filters are a very effective means of making the sky darker and revealing richer tones and colours. They can also reduce the contrast between a bright sky and a darker foreground giving improved tones and colours in both. Coloured versions of these filters can also be bought but they do need to be used with discretion as the results can very easily look unnatural and, unless used in the right circumstances, will tend to produce rather crude and obvious images.

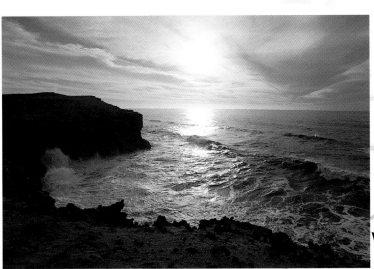

These two photographs of a seascape show the effect of using a tobacco-coloured graduated filter in order to add a touch of drama to an image which lacked an interesting colour.

Technical Details

▼ 35mm SLR camera with a 35–70mm zoom lens, a tobacco-coloured graduated filter and Kodak Ektachrome 64.

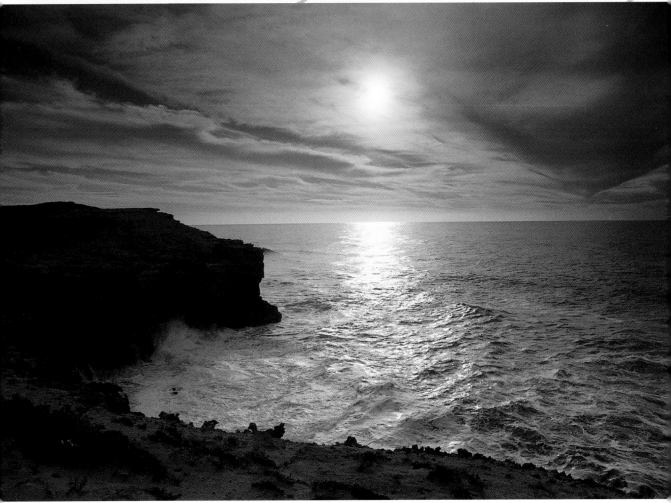

Storing your Photographs

Card mounts are the most suitable way of storing and presenting colour transparencies. They can be printed with your name and address together with caption information using labels. Added protection can be given by the use of individual clear plastic sleeves which slip over the mount.

Technique

Even the finest print will be improved by good presentation and mounting it flat onto a heavy weight card is the first stage using dry mounting tissue or spray adhesive. The addition of bevel cut-out mount on top will give it a very professional finish. You can cut these yourself to size using a craft knife, or there are special tools available, but they can also be bought ready-made in the most popular sizes from art stores. A group of prints finished in this way and nicely framed can look great on the walls of a home or office.

Rule of Thumb

A good photo library can reach infinitely more potential picture buyers than is possible for an individual and can also make sales to the advertising industry where the biggest reproduction fees are earned.

Technique

For purely personal use, many photographers use flip-over albums as a means of showing their prints. This method is, at best, simply a convenient way of storing prints and does nothing to enhance their presentation. It can be far more pleasing and effective to show a collection of images as a series of prints mounted on the pages of an album, choosing one large enough to allow six or more photos to be seen together on a spread.

There are a number of ways of selling your work and finding a potential outlet for your work in print. Good colour photographs of all manner of subjects, ranging from landscapes to plants and gardens, architecture and people are in constant demand by publishers of magazines and there is a ready market for most topics if the photographs are well executed.

Rule of Thumb

If you have a collection of photographs on a particular theme, such as how to make something, and can write perhaps 1000 words to accompany them you will have an excellent chance of placing them with the right type of publication.

The simplest way of storing mounted transparencies is in view packs – large plastic sleeves with individual pockets which can hold up to 24 35mm slides, or 15 120 transparencies. These can be fitted with bars for suspension in a filing-cabinet drawer and quickly and easily lifted out for viewing. For slide projection however it is far safer to use plastic mounts, preferably with glass covers, to avoid the risk of popping and jamming inside the projector.

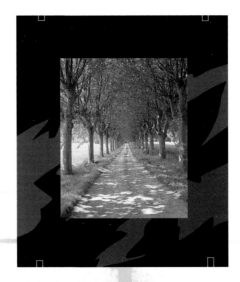

The different effects which can be created by changing the way a photographic print is mounted and presented are shown here.

Finishing & Presentation

One of the most striking ways of presenting a series of colour photographs on a particular theme is in the form of a photo essay. This is also an excellent way of helping to establish your approach to a subject and to develop a personal style.

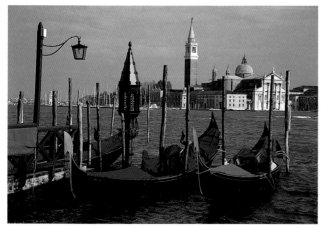

Technique

The essence of a photo essay is to present a series of images in a way in which each one enhances those adjacent to it, it helps to visualise the end product as being, perhaps, a series of images on a book or magazine spread or as a group of framed photographs on a wall.

Rule of Thumb

Look for ways in which you can vary the colour quality and composition of the images so that you are able to juxtapose them in the most effective way. Include both close-ups and long shots, wide-angle pictures with those more tightly framed and images which have different dominant colours. You are, effectively, designing a large image which is composed of many smaller ones, like tiles in a mosaic.

This photo essay on Venice was shot with lenses ranging from 24–300mm using Fuji Velvia and Kodak Ektachrome 100 SW and 100 VS.

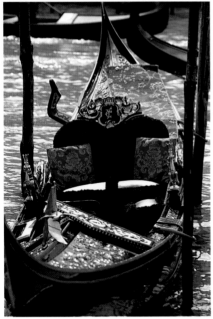

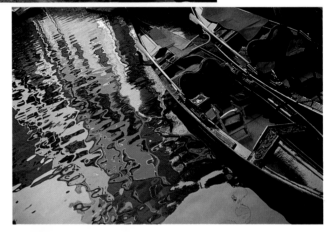

Glossary

Aperture Priority
An auto-exposure setting in which the user selects the aperture and the camera's exposure system sets the appropriate shutter speed.

APO lens
A highly-corrected lens which is designed to give optimum definition at wide apertures and is most often available in the better quality long-focus lenses.

Ariel Perspective
The tendency of distant objects to appear bluer and lighter than close details and enhancing the impression of depth and distance in an image.

Auto Bracketing
A facility available on many cameras which allows three or more exposures to be taken automatically in quick succession giving both more and less than the calculated exposure. Usually adjustable in increments of 1/3, 1/2 or 1 stop settings and especially useful when shooting colour transparency film.

Bellows Unit
An adjustable device which allows the lens to be extended from the camera body to focus at very close distances.

Black Reflector
A panel with a matt black surface used to prevent light being reflected back into shadow areas in order to create a dramatic effect.

Cable Release
A flexible device which attaches to the camera's shutter release mechanism and which allows the shutter to be fired without touching the camera.

Close-up Lens
This is a weak positive lens placed in front of a prime lens to enable it to be focussed at a closer distance than it is designed for. They can be obtained in various strengths and do not require an increase in exposure, as in the case of extension tubes and bellows units.

Colour Cast
A variation in a colour photograph from the true colour of a subject which is caused by the light source having a different colour temperature to that for which the film is balanced.

Colour Temperature
A means of expressing the specific colour quality of a light source in degrees Kelvin. Daylight colour film is balanced to give accurate colours at around 5,600 degrees Kelvin but daylight can vary from only 3,500 degrees K close to sundown to over 20,000 degrees K in open shade when there is a blue sky.

Cross Processing
The technique of processing colour transparency film in colour negative chemistry, and vice versa, to obtain unusual effects.

Data Back
A camera attachment which allows information like the time and date to be printed on the film alongside, or within, the images.

Dedicated Flash
A flash gun which connects to the camera's metering system and controls the power of the flash to produce a correct exposure. Will also work when the flash is bounced or diffused.

Depth of Field
The distance in front and behind the point at which a lens is focussed which will be rendered acceptably sharp. It increases when the aperture is made smaller and extends about 2/3 behind the point of focus and 1/3 in front. The depth of field becomes smaller when the lens is focussed at close distances. A scale indicating depth of field for each aperture is marked on most lens mounts and it can also be judged visually on SLR cameras which have a depth of field preview button.

Double Extension
The term used when the lens is extended beyond the film plane to twice its focal length by the means of macro focussing, extension tubes or a bellows unit to give a life-size image on the film. This requires four times the exposure indicated when the lens is focussed at infinity, but will be automatically allowed for when using TTL (through-the-lens) metering.

DX Coding
A system whereby a 35mm camera reads the film speed from a bar code printed on the cassette and sets it automatically.

Evaluative Metering
An exposure meter setting in which brightness levels are measured from various segments of the image and the results used to compute an average. It's designed to reduce the risk of under- or overexposing subjects with an abnormal tonal range.

Exposure Compensation
A setting which can be used to give less or more exposure when using the camera's auto-exposure system for subjects which have an abnormal tonal range. Usually adjustable in 1/3 of a stop increments.

Exposure Latitude
The ability of a film to produce an acceptable image when an incorrect exposure is given. Negative films have a significantly greater exposure latitude than transparency films.

Extension Tubes

Tubes of varying lengths which can be fitted between the camera body and lens used to allow it to focus at close distances. Usually available in sets of three different widths.

Fill In Flash

A camera setting, for use with dedicated flash guns, which controls the light output from a flash unit and allows it to be balanced with the subject's ambient lighting when it is too contrasty or there are deep shadows.

Factor

The amount by which the exposure must be increased to allow for the use of a filter. A x2 filter requires an increase of 1 stop and a x4 filter requires a 2 stop exposure increase.

Flash Meter

An exposure meter which is designed to measure the light produced during the very brief burst from a flash unit.

Grey Card

A piece of card which is tinted to reflect 18% of the light falling upon it. It is the standard tone with which exposure meters are calibrated and can be used for substitute exposure readings when the subject is very light or dark in tone.

Honeycomb

A grill-like device which fits over the front of a light reflector to restrict its beam and limit spill.

Hyperfocal Distance

The closest distance at which details will be rendered sharp when the lens is focussed on infinity. By focussing on the hyperfocal distance you can make maximum use of the depth of field at a given aperture.

Incident Light Reading

A method, involving the use of a hand meter, of measuring the light falling upon a subject instead of that which is reflected from it.

ISO Rating

The standard by which film speeds are measured. Most films fall within the range of ISO 25 to ISO 3200. A film with double the ISO rating needs one stop less exposure and a film with half the ISO rating needs one stop more exposure. The rating is subdivided into 1/3 of a stop settings i.e. 50, 64, 80 and 100.

Macro Lens

A lens which is designed to focus at close distances to produce up to a life-size image of a subject and is corrected to give its best performance at this range.

Matrix metering

See Evaluative Metering.

Mirror Lock

A device which allows the mirror of an SLR camera to be flipped up before the exposure is made to reduce vibration and avoid loss of sharpness when shooting close-ups or using a long-focus lens.

Polarising Filter

A neutral grey filter which can reduce the brightness of reflections in non-metallic surfaces such as water, foliage and blue sky.

Programmed Exposure

An auto-exposure setting in which the camera's metering system sets both aperture and shutter speed according to the subject matter and lighting conditions. Usually offering choices like landscape, close-up, portrait, action etc.

Pulling

A means of lowering the stated speed of a film by reducing the development times.

Pushing

A means of increasing the stated speed of a film by increasing the development times.

Reciprocity Failure

The effect when very long exposures are given. Some films become effectively slower when exposures of more than one second are given and doubling the length of the exposure does not have as much effect as opening up the aperture by one stop.

Reversing Ring

A device which enables an ordinary lens to be mounted back to front on the camera, which allows it to be focussed at very close distances and improves the definition.

Shutter priority

A mode on auto-exposure cameras which allows the photographer to set the shutter speed and the camera's metering system selects the appropriate aperture.

Snoot

A conical device which fits over the front of a light reflector to restrict its beam and limit spill.

Spot Light

A light source fitted with a lens which enables a precisely focussed beam of light to be projected.

Spot Metering

A means of measuring the exposure from a small and precise area of the image which is often an option with SLR cameras. It is useful when calculating the exposure from high-contrast subjects or those with an abnormal tonal range.

Substitute Reading

An exposure reading taken from an object of average tone which is illuminated in the same way as the subject. This is a useful way of calculating the exposure for a subject which is much lighter or darker than average.